Notable Acquisitions at

The Art Institute of Chicago

THE ART INSTITUTE OF CHICAGO *Museum Studies*

THE ART INSTITUTE OF CHICAGO *Museum Studies*

VOLUME 30, NO. 1

© 2004 by The Art Institute of Chicago

ISSN 0069–3235

ISBN 0-86559-209-8

Published semiannually by the Art Institute of Chicago Publications Department, 111 South Michigan Avenue, Chicago, Illinois 60603-6110.

Subscription rates are $25 for members of the Art Institute, $30 for other individuals, and $50 for libraries or businesses. Subscribers outside the U.S.A. should add $8 per year for postage. For more subscription information, contact (312) 443-3786 or pubsmus@artic.edu, or consult our subscription order form on the Art Institute's Web site at www.artic.edu /aic/books/msbooks.

In-print back issues can be purchased from the Art Institute of Chicago Museum Shop. For more information consult www.artic.edu /aic/ books/msbooks or call (800) 905-8537; wholesalers should call (800) 621-9337. In-print back issues can also be purchased from the Publications Department at the address above. Single copies are $16.95 each for individuals and $25 for libraries or businesses.

Available out-of-print issues are $50 each for all customers, and can be purchased only from the Publications Department. Orders from outside the U.S.A. should include $4 per copy for shipping by ground. Price incentives are available for bulk orders or selected complete sets. For more information contact (312) 443-3786 or pubsmus @artic.edu.

This issue of *Museum Studies* was made possible through a generous gift from The Community Associates of The Art Institute of Chicago. Ongoing support for *Museum Studies* has been provided by a grant for scholarly catalogues and publications from The Andrew W. Mellon Foundation.

Executive Director of Publications: Susan F. Rossen; Editor of *Museum Studies*: Gregory Nosan; Designer: Jeffrey D. Wonderland; Production: Sarah E. Guernsey; Subscription and Circulation Manager: Bryan D. Miller.

Volume 30, no. 1, was typeset in Stempel Garamond; color separations were made by Professional Graphics, Inc., Rockford, Illinois. The issue was printed by Meridian Printing, East Greenwich, Rhode Island, and bound by Midwest Editions, Minneapolis, Minnesota.

Front cover: *Willow Bridge and Water Wheel* (detail; pp. 40–41). Opposite: *Girl Looking out the Window* (detail; p. 71). Back cover, clockwise from top right: *Study for Ornamental Band No. 6* (detail; p. 25); *Alka Seltzer* (detail; p. 91); *Card Table* (detail; pp. 6–7); *Young Woman in a Garden* (detail; pp. 68–69).

Photography Credits

Contents

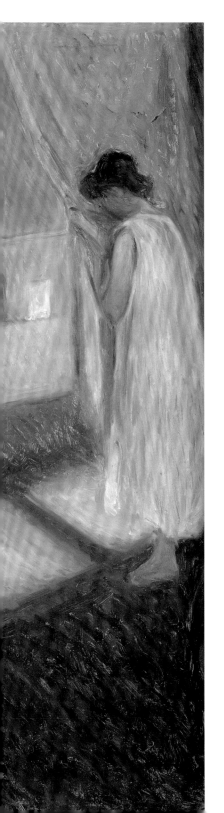

THE ART INSTITUTE OF CHICAGO

Museum Studies, Volume 30, No. 1
Notable Acquisitions at The Art Institute of Chicago

Preface

Founded in 1953 and now comprising sixteen local groups throughout the greater metropolitan area, The Community Associates of The Art Institute of Chicago work closely with the museum's education staff to offer our more than four thousand members unique opportunities for intellectual and aesthetic exploration. Local chapters presented more than one hundred fifty offerings in 2003–04 alone. These included a wide spectrum of lectures by Art Institute curators and educators on topics ranging from Renaissance jewelry and paintings conservation to Japanese screens and filmmaking in Chicago. They were complemented by two major events organized annually by the Community Associates Executive Board with the goal of bringing individual chapters together. This year the Combined Associates Lecture, which introduces members to the thought and work of important contemporary artists, was delivered by longtime collaborators Claes Oldenburg and Coosje van Bruggen. In addition, the Community Associates and The Women's Association of the Chicago Symphony Orchestra cosponsored a seminar highlighting the special exhibition *Rembrandt's Journey*, which combined a lecture and gallery viewing at the Art Institute with a program surveying seventeenth-century organ music at Symphony Center.

Although not fund-raising groups per se, Community Associates chapters contribute to a Long Range Fund that is used to underwrite small-scale projects that we believe will enhance appreciation and deepen understanding of the Art Institute's permanent collection. Since establishing the Long Range Fund in 1995 and the Research and Lecture Series two years later, we have made possible a significant number of conservation, adult education, and research initiatives that might otherwise have gone unsponsored. In addition to supporting both this edition of *Museum Studies* and its companion issue, we have also been able to help for-ward the work of every curatorial department surveyed in this publication. Among other projects, the Community Associates have funded research and lectures on John Singer Sargent, decorative arts, and still-life painting in the Department of American Arts; on Marion Mahoney Griffin and the David Adler archive in Architecture; on Japanese prints in Asian Art; on works by Francisco Goya and El Greco in European Painting; and on seventeenth-century Italian drawings, early German lithographs, and Mexican prints in the Department of Prints and Drawings. Gifts from the Long Range Fund have also supported departmental projects involving the conservation of Japanese paintings and true-to-period upholstery of eighteenth-century American furniture.

Given our commitment to education and research, it is most appropriate—and with great pleasure—that we introduce this edition of *Museum Studies*, the second of a two-issue project devoted to cataloging noteworthy acquisitions made between 1992 and 2003. We extend our deep thanks to the Art Institute's curators and its Director and President, James N. Wood, for their outstanding stewardship of the permanent collection. We hope these twin publications serve not only as a fitting celebration of their accomplishments but also play an important role in educating both the museum's members and the wider scholarly community.

GAIL A. PEARSON

Executive Chairman
The Community Associates of The Art Institute of Chicago, 2004–06

Introduction and Acknowledgments

With the previous edition of *Museum Studies*, the Art Institute began a two-issue project devoted to cataloging some of the finest objects added to the museum's collection between 1992 and 2003. It is my pleasure to introduce the concluding half of this effort, which here surveys outstanding works acquired by the departments of American Arts, Architecture, Asian Art, European Painting, and Prints and Drawings.

One of the main components of the Art Institute's mission is to offer visitors a chance to experience, in person, original examples of the greatest achievements in the arts. Another is to enhance the museum's permanent collection, adding to our holdings of a recognized artist's oeuvre, advancing our knowledge of underrepresented genres or cultures, and seeking out important new works. The objects in this issue reflect these goals and testify to the generosity of the benefactors who help the Art Institute realize them. The presence of such acquisitions in these pages, and in the museum itself, also reveals the commitment of our curatorial staff, who combine scholarly acumen and knowledge of the art world in their efforts to augment our collection with the most significant artworks available.

Indispensible to this project were the interpretive talents of those curators and researchers, many of whom were instrumental in acquiring the very objects they wrote on. Thanks go to the following authors for their many contributions to the publication: Brandy S. Culp and Sarah E. Kelly in the Department of American Arts; John Zukowsky in the Department of Architecture; Janice Katz, Elinor Pearlstein, and Betty Seid in the Department of Asian Art, and Stephen Little, formerly of that department and now director of the Honolulu Academy of Arts; Mary Weaver Chapin, Larry J. Feinberg, Gloria Groom, and Martha Wolff in the Department of European Painting; and Jay A. Clarke, Douglas Druick, Suzanne Folds McCullagh, Mark Pascale, and Martha Tedeschi in the Department of Prints and Drawings.

The expertise of other museum staff was equally important. Thanks go to Caroline Nutley and her colleagues in the Department of Imaging, and in the Department of Graphic Design and Communication Services to Jeffrey Wonderland, who continues to enhance the visual presence of *Museum Studies* in every way. In the Publications Department we are indebted to Sarah E. Guernsey, who guided the production of this issue with grace and good sense; to Shaun Manning, who ably handled photography rights; to Gregory Nosan, the journal's fine editor; and to Susan F. Rossen, who originated the idea of publishing two companion issues on new acquisitions in the first place.

This project benefited most of all, however, from the generous financial support of The Community Associates of The Art Institute of Chicago, a group whose devotion to education has taken a number of important shapes over the last fifty years. From the beginning, Associates groups have come together on a local level, studying art history, coming to know the museum and its collection more closely, and extending its influence into their own lives and communities. More recently they have used their resources to fund a significant series of lectures and research initiatives that contribute to the Art Institute's educational mission in meaningful ways. I offer my continued thanks to the Community Associates for their dedication to this museum during my time here, and wish them all the best in the many years ahead.

JAMES N. WOOD

Director and President
The Art Institute of Chicago

Card Table

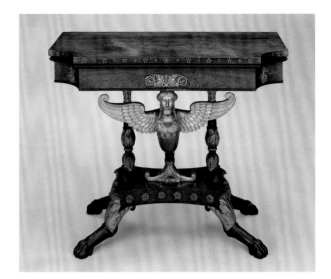

1815/19

Charles Honoré Lannuier
(French; 1779–1819)
Mahogany with rosewood veneer, giltwood, brass and ebony
inlay, ormolu; 77.8 x 91.1 x 45.1 cm (30 5/8 x 35 7/8 x 17 3/4 in.)
Inscribed: *Hre. Lannuier, Cabinet Maker from Paris Kips [H]is
Whare house of new fashion fourniture Broad Street, No. 60,
New-York. / Hre. Lannuier Ebéniste de Paris Tient Fabrique &
Magasin de Meubles les plus à la Mode, New-York*
(on the engraved label on the underside of the tabletop)

RESTRICTED GIFT OF JAMEE J. AND MARSHALL FIELD;
PAULINE ARMSTRONG ENDOWMENT, 1994.712

Trained as a cabinetmaker in Paris, Charles Honoré Lannuier arrived in New York in 1803 at the age of twenty-four. According to his advertisement in the *New York Evening Post*, he brought with him from France "gilt and brass frames, borders of ornaments and handsome safelocks, as well as new patterns."[1] These novel designs were undoubtedly in the French Empire style popularized by Charles Percier and Pierre F. L. Fontaine's *Recueil des décorations intérieures* (first published in 1801) and Pierre de la Mésangère's *Collection des meubles et objects de goût* (released serially between 1796 and 1830). Unlike the delicate, attenuated Neoclassicism espoused by the British designers Robert Adam, George Hepplewhite, and Thomas Sheraton, the emerging Empire style was a heavier, richer, more literal interpretation of ancient cultures, particularly those of Egypt and Rome.

Lannuier, like many other French tradesmen, immigrated to America to escape the political and social turmoil that followed the Revolution. New York was an attractive destination for the furniture maker not only because it was a favorable market for French luxury goods, but also because his older brother was already well established as the owner of a successful confectionery shop on Broadway. It was from this store that the young entrepreneur first advertised his services to all potential clients who desired furniture in the "latest French fashion."[2]

The Art Institute's card table illustrates Lannuier's successful transition to the nascent Empire aesthetic from the more severe Neoclassical style in which he was trained. Early-nineteenth-century America was much enamored with the French taste, and Lannuier successfully catered to his upscale clientele, tempering his designs to suit their preferences even as he retained a distinctive French flair. One of a group of similar card tables, this example shares many of their decorative and design elements, most notably hollowed tabletop corners; a winged caryatid central support (a Lannuier trademark); and ormolu, or gilt bronze, mounts placed along the table skirt.[3] Lannuier painted the animal-paw feet in *vert antique*, a greenish tinting used to resemble patinated bronze. Associated with Classical cultures, it was meant to imitate the corroded surfaces of ancient metal furniture and decorative objects.

BRANDY S. CULP

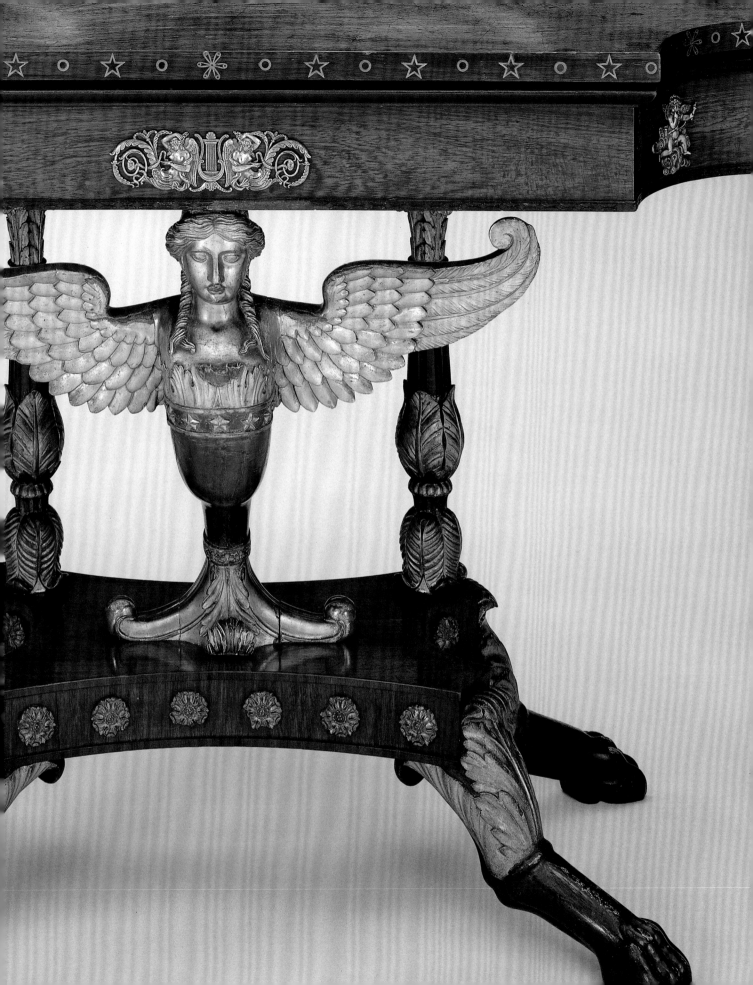

Zenobia, Queen of Palmyra

Modeled 1857/59

Harriet Hosmer
(American; 1830–1908)
Marble; 86.3 x 57.2 cm (34 x 22 ¹/₂ in.)

GIFT OF THE ANTIQUARIAN SOCIETY, 1993.260

I honor every woman who has strength enough to step outside the beaten path when she feels that her walk lies in another," said Harriet Hosmer, in a remark that applied as strongly to the independent life she lived as to the commanding female subjects she portrayed.[1] Raised with unusual freedom by her widower father, the unconventional artist flouted social constraints by wearing masculine clothing and enjoying an active life outdoors as a horsewoman and swimmer. An expatriate who settled in Rome, she became the leader of a small group of female artists who found inspiration in ancient Greek and Roman sculpture. Although determined to equal their male colleagues in the complexity and excellence of their neoclassical work, they were described disparagingly by the novelist Henry James, who referred to them as "that strange sisterhood of American 'lady sculptors' who at one time settled upon the seven hills [of Rome] in a white, marmorean flock."[2]

Zenobia, Queen of Palmrya represents the pinnacle of Hosmer's achievement and depicts the famed queen of antiquity whose acts of rebellion against the Roman Empire led to her capture. She was then paraded in shackles through the streets of the capital. Reflecting the dominant attitudes of the age, nineteenth-century authors emphasized what they took to be Zenobia's unseemly ambition, implying that she deserved her downfall.[3]

Instead of portraying the queen as weak or flawed, however, Hosmer accentuated her honor and strength, remarking, "I have tried to make her too proud to exhibit passion or emotion of any kind; not subdued, though a prisoner; but calm, grand, and strong within herself."[4]

Hosmer originally carved a seven-foot, full-length marble figure of Zenobia in chains (modeled 1857/59; unlocated), which she exhibited to great acclaim in New York, Boston, and Chicago.[5] This heroic bust is one of the many highly profitable, reduced-size versions that she produced for American patrons. Removing both the chains and the narrative element they introduced, Hosmer used the bust format to emphasize her subject's dignity, delicately modeling her face, hair, and drapery.

The critical enthusiasm that *Zenobia* inspired, however, led to professional jealousy and the published accusation that Hosmer relied too much on the assistance of Italian workmen.[6] Although many sculptors in Rome employed marble carvers to produce the final versions of the models they had conceived in clay, such charges were not leveled at Hosmer's male counterparts. In a characteristically determined move, the artist protested the slander, earning a retraction and the opportunity to publish a rebuttal in which she emphasized the hands-on role she played in creating her marble sculptures.[7]

SARAH E. KELLY

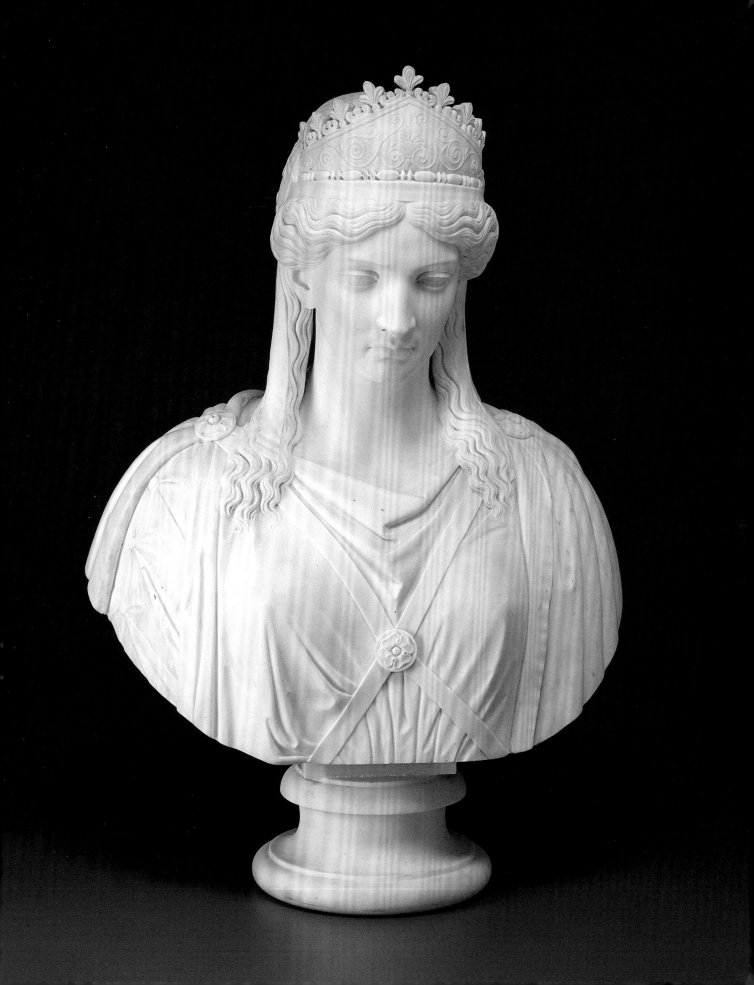

Machinist and Machinist's Apprentice

c. 1859

Emma Stebbins
(American; 1815–1882)
Marble; 74.9 x 29.2 x 29.2 cm (29 1/2 x 11 1/2 x 11 1/2 in.) and
74.9 x 29.9 x 22.9 cm (29 1/2 x 11 3/4 x 9 in.)

GIFT OF THE ANTIQUARIAN SOCIETY, 2000.13.1–2

This rare pair of marble statues portrays a laborer and his apprentice, an unusual theme in mid-nineteenth-century American sculpture. Emma Stebbins's innovative conceit was to render a modern subject—the new profession of the machinist—in a refined, neoclassical visual language that was traditionally used to depict biblical, historical, or mythological subject matter.

Like Harriet Hosmer (see pp. 8–9), Stebbins was a member of the community of women sculptors in Rome, who, like their male colleagues, emulated the statues of antiquity, seeing in them the highest form of art.[1] She began her career as a painter but turned to sculpture in 1857 after moving to Rome. In 1859, the coal-mining tycoon Charles Heckscher commissioned her to create a pair of allegorical figures of modern life: *Industry* and *Commerce*, figured respectively as a miner and a sailor, were exhibited to critical acclaim at the Goupil Gallery, New York, in 1861.[2] Although the circumstances under which Stebbins carved *Machinist and Machinist's Apprentice* are still unclear, it seems likely that she produced the pair as a speculative venture, hoping to find a purchaser among the growing class of wealthy American industrialists.

Both figures can be identified as machinists by their clothing: cap, work shirt, leather apron, and long pants. The senior, set in a contrapposto stance reminiscent of Hellenistic statues, holds a forging hammer and toothed gear, the means and end of his labor. The younger apprentice, with bent leg perched on an Ionic column, shows his ability to improve upon his elder's teachings by using his compass and drawing stylus to create new mechanical designs.

In the 1850s the role of the machine in a newly industrializing America was hotly debated, with critics worrying that the perceived tyranny of mechanization threatened the nation's distinctive work ethic.[3] Stebbins's sculptures seem to address those fears and suggest a positive outcome. By using a neoclassical idiom to represent a new, machine-based profession practiced by two generations of workers, Stebbins affirmed traditional labor even as she celebrated the possibilities of beneficial innovation. Furthermore, her synthesis of the language of antiquity and a profession of modernity served to legitimate her choice of subject matter. Yet it also offered neoclassical sculpture—already facing perceptions of being outdated—a contemporary relevance that was, for better or for worse, seldom pursued by her fellow sculptors.

SARAH E. KELLY

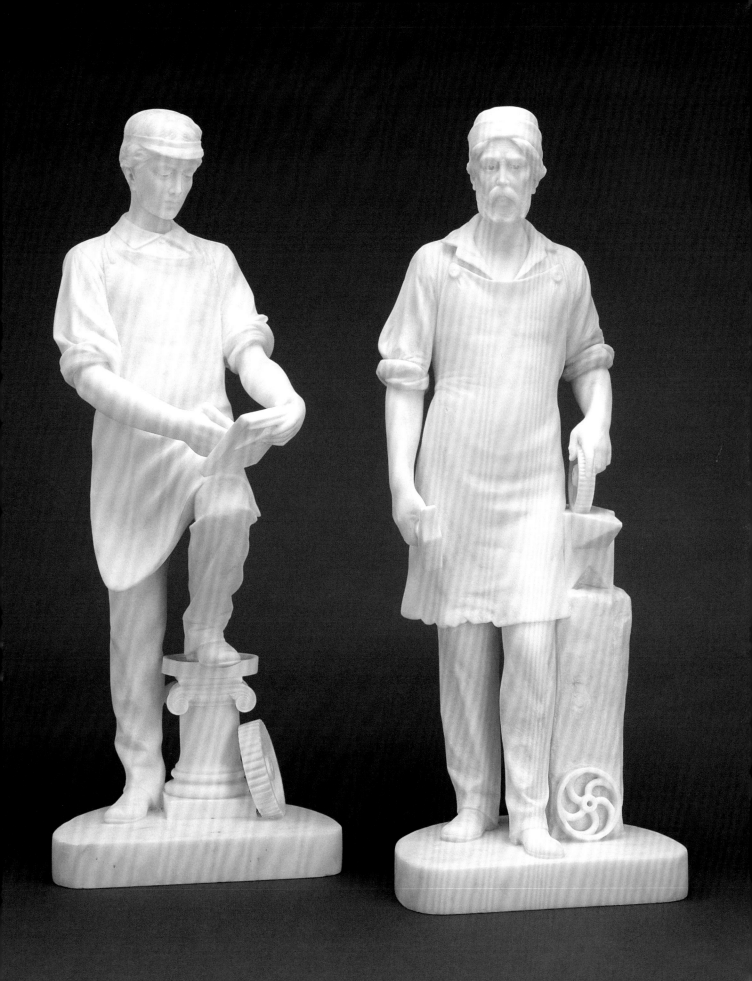

Fruit Piece

1860

Hannah B. Skeele

(American; 1829–1901)

Oil on canvas; 50.8 x 60.6 cm (20 x 23 7/8 in.)

RESTRICTED GIFT OF CHARLES C. HAFFNER III,
MRS. HAROLD T. MARTIN, MRS. HERBERT A. VANCE AND
MRS. JILL B. ZENO; THROUGH PRIOR ACQUISITION OF
THE GEORGE F. HARDING COLLECTION, 2001.6

Like many other still-life paintings of its era, *Fruit Piece* reveals the interests and ambitions of the American patron who purchased it. It also attests to the active and successful careers enjoyed by women artists, whose work has often been overshadowed by the passage of time. Born in Maine, the now little-known Hannah Skeele emerged as an artist in St. Louis in 1858, where she painted still lifes, portraits, and animal compositions before continuing her career in her native state after 1870.[1] The crisp clarity of Skeele's rendition and her talent for representing a variety of textures and colors brought her work critical acclaim and sales throughout her lifetime.

Skeele exhibited *Fruit Piece* at the Western Academy of Art, St. Louis, in 1860, when it was already in the collection of the local businessman Edgar Ames; it is her earliest documented painting, and one of her finest. On a shallow table, Skeele presented three vessels of different media, demonstrating her ability to render deftly in paint a range of tactile and visual qualities—the transparency of glass, the fragile delicacy of porcelain, the sheen of silver. The contents also convey a diversity of shapes and colors: tender, red strawberries, a prickly pineapple, a green, underripe banana, and its ripened counterpart. The rich, saturated colors give the composition a gemlike glow.

The painting is a professional triumph, displaying Skeele's skill for all to see.

Fruit Piece can also be understood within the context of its owner's social status. Still-life paintings of fruits, vegetables, and game were considered "dining room pictures"; like the furniture and table settings they surrounded, they would have helped a host advertise his ability to provide lavishly for his family and guests.[2] Indeed, most of the delicacies displayed in *Fruit Piece* were luxury items popular during the hot summer. Furthermore, strawberries were an indigenous crop and carried nationalistic associations, while the exotic fruits in the central bowl attest to the prominence of international trade. In addition to owning one of St. Louis's largest packaging businesses, Ames was a prominent patron of the arts and sciences, which alone enabled him to promote himself as a man of refinement. But the content of this specific painting suggests Ames's broader pretensions: by displaying it, he could subtly assert his American allegiances, his ability to purchase expensive, imported fruits, and his sophisticated culinary tastes.

SARAH E. KELLY

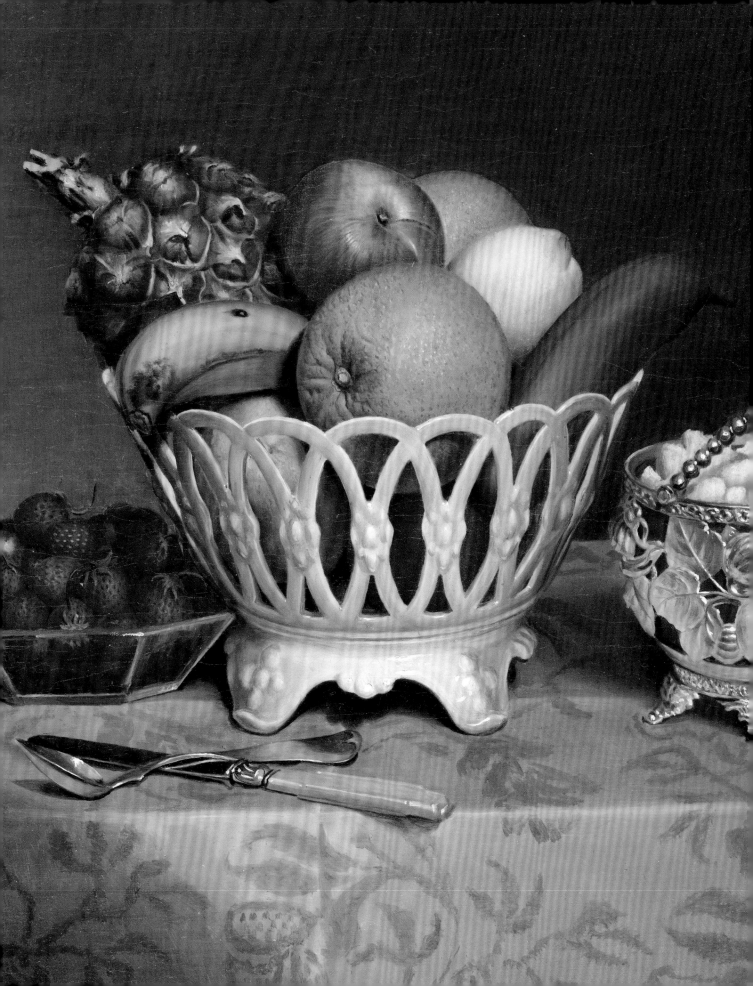

Double-Plated Lamp

c. 1865

Boston and Sandwich Glass Company
Sandwich, Massachusetts
Cobalt blue, opaque white, and clear glass, gilt bronze, marble;
h. 97.8 cm (38 ¹/₂ in.) to top of shade

THROUGH PRIOR ACQUISITION OF EMILY CRANE
CHADBOURNE, ARTHUR HEUN, MRS. MAURICE B.
MANDELBAUM, DR. AND MRS. ROY NAGLE, AND
MRS. HOWARD PEABODY, 1994.5

As it was common for nineteenth-century households to have only a single source of illumination in each room, light was a precious commodity.[1] Replacing whale-oil burners in the 1860s, kerosene lamps were most commonly made of glass; users often positioned them at the center of a table, where they served as a focus of evening activities. The monumentality of this particular lamp, however, suggests that it was no ordinary lighting device, but instead a symbol of its owners' taste and social status. Today, very few lamps of this size are known to exist.

Made using the overlay method, the lamp is a rare, spectacular example of nineteenth-century double-plated glass and a tour de force of technique and design. In the overlay process, colorless glass is encased in one or more layers of colored glass. These layers, one blown into the other, are reheated and fused together; then, while the glass is still warm, it is forced into a mold. After cooling, patterns are cut through the top layers, exposing each colored overlay and the colorless glass underneath. In this example a rich cobalt blue was layered over an opaque white, which in turn encases the clear glass. A wholesale catalogue describes the incised pattern on the Art Institute's lamp as "Cut-Punty and Diamond-Flint"; the term "punty" names the circles, "diamond flint" the crosses.[2] Though hand-cut on a glass cutter's wheel, which required great precision and skill, this pattern is miraculously uniform throughout. The lamp's body rests on a triple-stepped marble base with gilt-bronze mounts.

The Boston and Sandwich Glass Company (1826–1888) was one of the largest manufacturers of domestic glass at mid-century and produced a broad array of such lamps in various colors, shapes, and sizes. Responding to the popularity of imported glassware from Bohemia, the firm began experimenting with glass overlay techniques in the 1840s. By the late 1850s, the company had perfected its own glass formulas and plating processes, which it used to create a variety of kerosene lamps. Massive, high-style models such as this one were made in small numbers for wealthy clients, who could afford to pay the steep asking price and also hire servants to maintain them.

BRANDY S. CULP

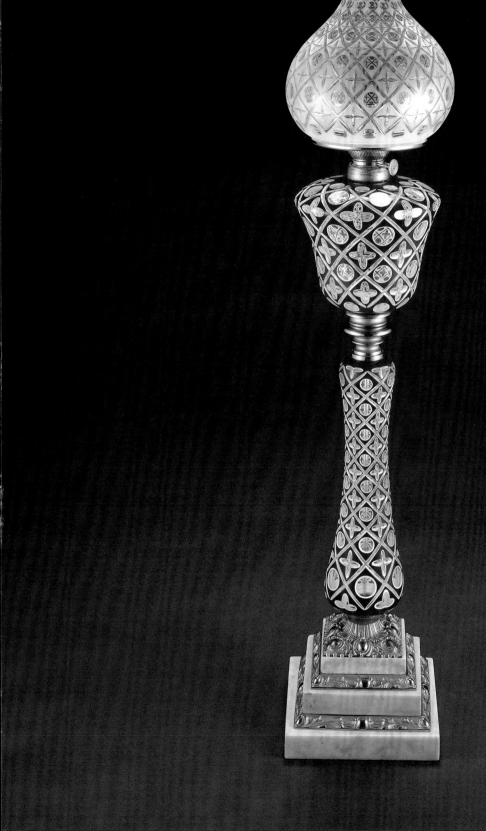

York Harbor, Coast of Maine

1877

Martin Johnson Heade

(American; 1819–1904)

Oil on canvas; 38.7 x 76.8 cm (15 ¼ x 30 ¼ in.)

RESTRICTED GIFT OF MRS. HERBERT A. VANCE;
AMERICANA, LACY ARMOUR, AND ROGER McCORMICK
ENDOWMENTS, 1999.291

Painted with great subtlety, *York Harbor, Coast of Maine* represents a quiet inlet punctuated by three sailing sloops, cast in a cool, hazy light that unifies the tranquil composition. On a formal level, it can be understood as the painted embodiment of the metaphysical doctrines of American Transcendentalism; it also obliquely addresses the changing economic status of the New England landscape. Martin Johnson Heade, celebrated equally for his spare marsh scenes and lush portrayals of orchids and hummingbirds, here displays his mature style in a landscape of serene yet eerie beauty.[1]

Modern scholars have long associated Heade's paintings with Luminism, a twentieth-century term consistently linked to Transcendentalism.[2] Admirers of the latter movement rejected the empiricist philosophy of John Locke and looked inward for higher spiritual truths. For them, nature and spirituality were inseparable; the con-

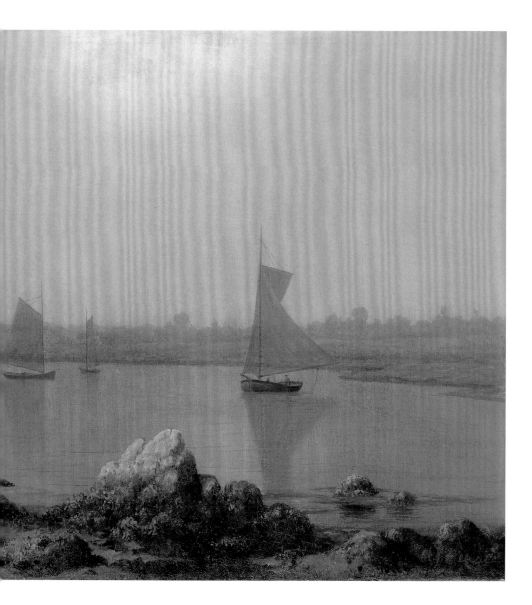

templative mind could attain transcendence through the experience of the natural world. Ralph Waldo Emerson famously attempted to describe the sensation of this unity: "Standing on the bare ground, my head bathed by the blithe air, and uplifted into infinite space—all mean egotism vanishes. I become a transparent eye-ball; I am nothing; I see all; the currents of the Universal Being circulate through me; I am part or particle of God."³ *York Harbor* evinces what are seen as the formal qualities of Luminism: a horizontal format, tight, invisible brush-work, and pervasive light. Sky and sea have the same visual impact, while the boats, reeds, and rocks construct similar verticals, producing a seascape of stilled, hushed power. In line with Emerson's thinking, Heade equalized all the elements of the landscape, as if to draw attention to nature's order and allow for spiritual reflection in a world without movement.

In addition, Heade offers a selective view of the sea at a time when development threatened the serenity of the New England coastline. In the period after the Civil War, the seashore offered travelers an escape from an increasingly industrialized culture. Yet the artist, an ardent conservationist and sportsman, lamented the ruinous effect of both tourism and commerce on the shrinking wilderness of New England. In York Harbor, he chose a site that appealed to neither vacationers nor developers, portraying instead three fishing boats quietly plying their trade. In a sense, then, he presented a nostalgic memory, frozen in time and space, of a simpler moment when land, sea, and labor existed in harmony.

SARAH E. KELLY

Vase

1882/90

Ott and Brewer
Trenton, New Jersey
Belleek porcelain with hand-painted gold-paste decoration;
h. 24.8 cm (9 3/4 in.)
Marks: *Ott & Brewer / Belleek* with a single crown dissected
by a sword (on bottom)

RESTRICTED GIFT OF MRS. HAROLD T. MARTIN, 2002.280

This subtly iridescent green vase was made of Belleek, a light, extremely thin porcelain that is lustrous or cream-colored in appearance. Originally produced in Ireland with clay ingredients indigenous to the British Isles, Belleek was named for the town in which it was first created. Sold and exhibited in the United States in the 1870s, Irish Belleek was highly prized among collectors and much acclaimed by the press, achieving a popularity that prompted American ceramists to imitate it. Native manufacturers were already producing porcelain with imported European materials, but Belleek was uncommonly delicate in comparison, and its formula remained a mystery.

In 1882, after much experimentation, Ott and Brewer became the first firm to create a true facsimile of Irish Belleek. During earlier attempts the company had hit upon "ivory porcelain," which it introduced in 1876 and celebrated as the first all-American offering of its type, since all of its ingredients were obtained in the United States.[1] However, it was not until the company retained the services of the ceramist and Belleek native William Bromley, Jr. (and those of his father and brother John as well), that it was able to develop a porcelain that truly rivaled the Irish wares.[2] Elite consumers coveted Ott and Brewer's new Belleek, and could purchase it only at highly fashionable retailers such as Tiffany and Company, and Black, Starr, and Frost, both located in New York City.

The bulbous form of this square-necked vase complements its delicately painted, Japanese-inspired decoration. Such ornament was popularized by the artists and designers of the Aesthetic Movement, who looked to Japan in particular for inspiration and favored the flattened, abstracted, or asymmetrical compositions often seen in Japanese prints and decorative arts. The vase's uncommon, dark-green glaze differs from the opalescent variety most often used on Belleek, which resembles the inside of a seashell; it also provides a dramatic contrast to the delicate, gold-paste morning glories that entwine with the flowering reeds extending up the neck of the vessel. Like most American porcelains, this vase was not thrown on a wheel, but instead cast in a porous, plaster-of-paris mold. The technique required great skill but insured the eggshell quality for which Belleek wares were renowned.

BRANDY S. CULP

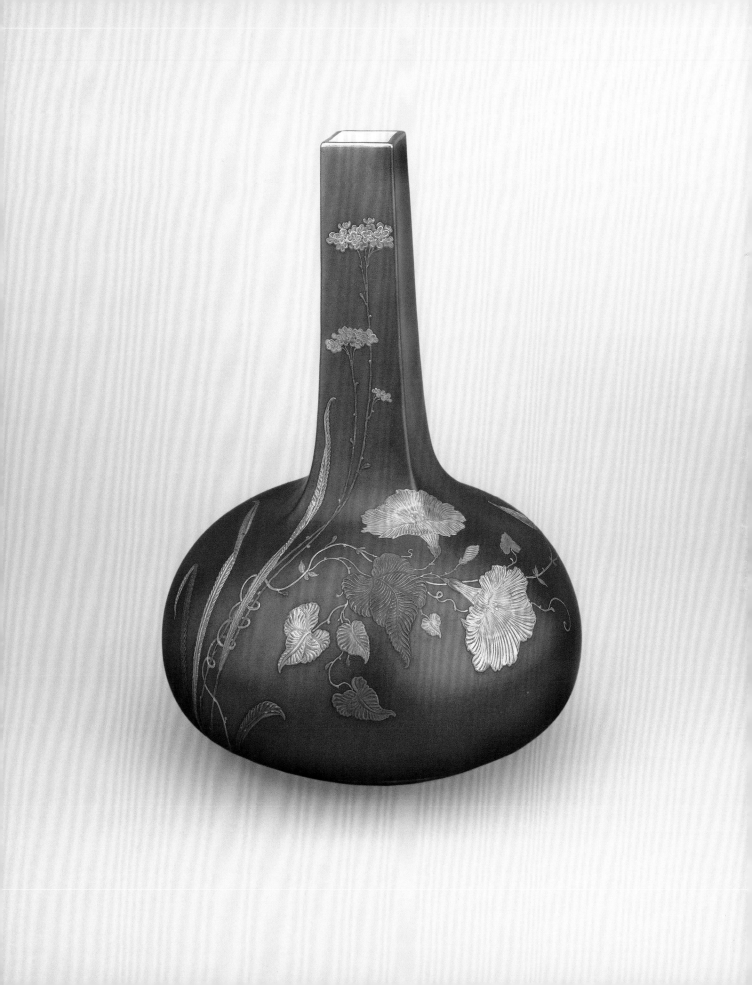

The Civil War Regalia of Major Levi Gheen McCauley

1887

George Cope
(American; 1855–1929)
Oil on canvas; 127 x 92.7 cm (50 x 36 1/2 in.)

MR. AND MRS. ROBERT O. DELANEY AND CHAUNCEY
AND MARION McCORMICK FUNDS; WESLEY M. DIXON
ENDOWMENT, 2000.134

By the 1880s, the Civil War had been transformed from a painful national event to a focus of collective nostalgia. Sharing in an era of civic remembrance, American artists such as George Cope often relied upon trompe l'oeil techniques to commemorate the war and its heroes, creating illusionistic depictions of aging military relics. A Quaker painter who was largely self-taught, Cope lived in West Chester, Pennsylvania, and specialized in still life and landscape.[1]

This canvas was Cope's first documented trompe l'oeil commission, offered to him in 1887 by his friend Levi Gheen McCauley, a decorated Civil War veteran and prominent citizen of West Chester. Cope anchored his carefully balanced composition with McCauley's two crossed swords—a foot officer's sword on the left and a cavalry saber on the right. Above these he positioned the major's hat, a kepi, which is embroidered with his Seventh Regiment insignia and corps badge, the Maltese Cross. McCauley's leather belt and revolver holster dangle below, anchored by a canteen marked with a 7. The artist wrapped a tasseled purple sash sinuously around these disparate objects, unifying his arrangement. Finally, he accorded his friend's two cherished decorations, the Military Order of the Loyal Legion of the United States and the Insignia of the Grand Army of the Republic, pride of place at the top of the painting.

These military artifacts function as a portrait of McCauley not by displaying an image of the man himself, but by recalling his heroic actions on behalf of the nation.[2] The major fought bravely for the Union, losing his right arm in 1864. As a community leader, he obviously took pride in his military service and wanted to commemorate it publicly. The feelings that prompted McCauley's commission reflected a concurrent wave of nostalgia for the Civil War, which took a wide range of forms: paintings, panoramas, and cycloramas depicting battle scenes; the installation of sculptures and monuments in public settings; and the establishment of national parks, museums, and holidays commemorating the men and deeds of the war.[3] After its completion the painting was exhibited in Philadelphia at Bailey, Banks, and Biddle, a distinguished jeweler that also manufactured McCauley's medals. The artifacts project a powerful melancholy, honoring the past in its glory and tragedy.

SARAH E. KELLY

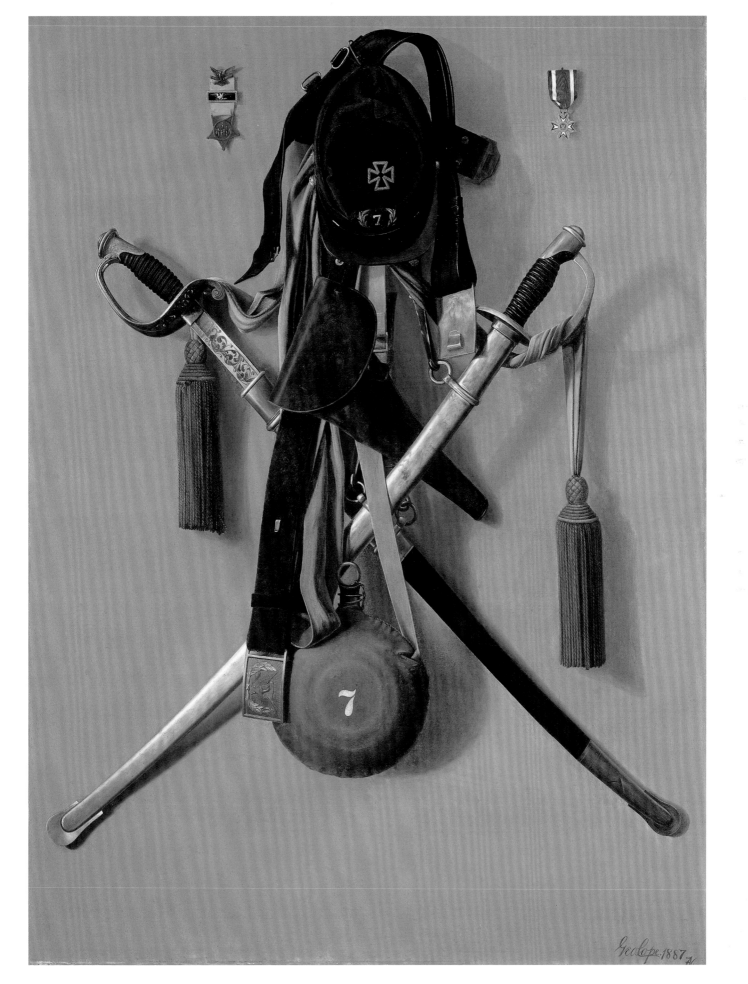

Hall Chair

c. 1900

Charles Rohlfs
(American; 1853–1936)
Oak with original black stain; 144.8 x 48.3 x 38.7 cm
(57 x 19 x 15 ¼ in.)
Stamped: *R* (twice on the front apron, once in red and once in
black, within a bow saw)

GIFT OF THE ANTIQUARIAN SOCIETY THROUGH
MRS. ERIC OLDBERG AND MR. AND MRS. MORRIS S.
WEEDEN, 1998.2

It was only after Charles Rohlfs married the novelist Anna Katharine Greene, gave up his professional acting pursuits, and moved from New York City to Buffalo that he turned his woodworking hobby into a profession.[1] Together Rohlfs and his new wife set about planning the interior of their own home. The couple desired high-quality furniture of good design but were unable to afford it, so Rohlfs set up a woodworking shop in his attic. Soon afterward he began to create furniture for friends and neighbors on commission, and by 1898 what had started as a personal venture had become a commercial endeavor.

The first of Rohlfs's exhibitions to receive national notice was held at Chicago's Marshall Field and Company department store. In January 1900 *House Beautiful* reviewed the show favorably, noting that the furniture, "while it is roughly executed . . . has originality and a certain distinction."[2] Among the many items displayed for sale was a hall chair similar to the one now in the Art Institute's collection. In the next decade and a half, Rohlfs gained acclaim at home and abroad. The Berlin newspaper *Norddeutscher Allgemeine Zeitung*, for example, pronounced him "the most original man in America" and asserted that "without planning to create a new style he has created one."[3]

Rohlfs capitalized on these claims of originality and was quick to reject associations between his work and that of other craftspeople. "My designs are my own," he asserted adamantly, citing nature as his primary source of inspiration.[4] However, he undoubtedly expressed an Arts and Crafts aesthetic in his use of quarter-sawn oak and exposed joinery, and also followed the lead of Vienna Secessionist designers in his use of flat decorative expressions. Moreover, his work often incorporates a variety of styles and decorative motifs ranging from medieval to Art Nouveau, Moorish to Asian.

The slender, dramatic form of the Art Institute's high-back chair immediately calls to mind the furniture of the Scottish architect, designer, and painter Charles Rennie Mackintosh. Its peculiar ornamentation, however, seems more influenced by nature than by Mackintosh's work. The hand-carved decoration on the backsplat, for instance, consists of what appear to be elongated, abstracted leaf-and-stem motifs, while sinuous curves rise up the legs like billowing smoke. Unlike fellow Arts and Crafts artisans, Rohlfs embraced rather than eschewed the use of heavy ornament. Although one of his clients probably commissioned this piece, Rohlfs owned a similar example, which appears in a photograph of his Buffalo home.[5]

BRANDY S. CULP

Yes, please enter my subscription to MUSEUM STUDIES, the Art Institute's journal.

		One Year (2 *issues*)
Volume 31 (2005)	Art Institute Member	☐ $25
will include two issues:	Individual (nonmember)	☐ $30
Victorian Art (spring issue)	Libraries or Businesses	☐ $50
Symbolist Art (fall issue)		

Subscribers outside the U.S.A. should add $8.

Note—*Museum Studies* subscriptions are nonrefundable.

Please check one: ☐ New ☐ Renewal

TOTAL ORDER $ _____

☐ Check enclosed (make check payable to MUSEUM STUDIES)

Charge credit card: ☐ MasterCard ☐ Visa ☐ American Express

ACCT. NO. _____

SIGNATURE _____

EXP. DATE _____

NAME _____

ADDRESS _____

CITY _____ STATE _____ ZIP _____

E-MAIL _____

Vol. 31

phone 312-443-3786 fax 312-443-1334 pubsmus@artic.edu www.artic.edu/aic/books/msbooks

BUSINESS REPLY MAIL
FIRST-CLASS MAIL PERMIT NO. 43708 CHICAGO IL

POSTAGE WILL BE PAID BY ADDRESSEE

MUSEUM STUDIES
PUBLICATIONS DEPARTMENT
THE ART INSTITUTE OF CHICAGO
I I I S MICHIGAN AVE
CHICAGO IL 60603-9736

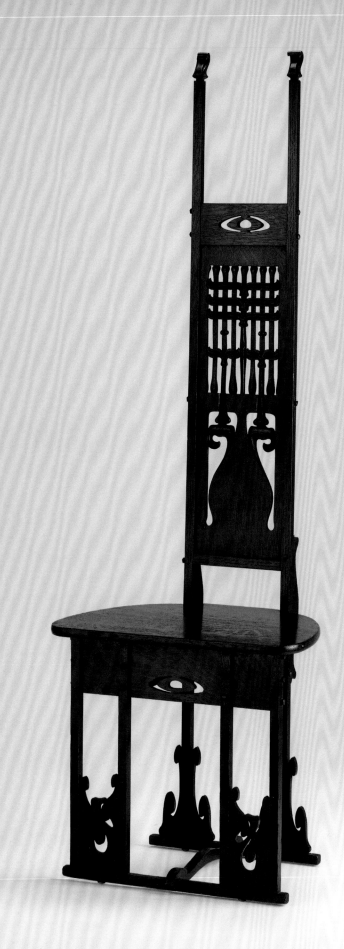

Study for Ornamental Band No. 6, McVickers Theater, Chicago, Illinois

1883/91

Louis H. Sullivan
(American; 1856–1924)
Graphite on paper; 36 x 21 cm (13 5/8 x 8 1/4 in.)

PURCHASE OF THE DIRECTOR'S FUND THROUGH
THE COMMITTEE ON MAJOR ACQUISITIONS, 1997.454.1

Louis Sullivan, one of America's great architectural individualists, is perhaps best known for the elaborate, almost lettucelike ornamentation of buildings such as the landmark Carson Pirie Scott department store on State and Madison streets in Chicago (1899–1904).[1] Essentially, Sullivan believed that all natural forms had an underlying, often bilateral, geometry; this idea served as the basis for most of his ornamental design, which culminated in his famous treatise, *A System of Architectural Ornament* (1924).

The bulk of Sullivan's drawings and papers were given to the Art Institute by the executor of his estate, the architect George Grant Elmslie. Among these documents are drawings from Sullivan's student days at the École des Beaux-Arts, Paris, in the mid-1870s; his fledgling Chicago career of the late 1870s and early 1880s; and his very late projects, undertaken between roughly 1900 and 1920. What the museum's collection lacks, however, is a series of several dozen sketches that Sullivan gave to his most prominent student, Frank Lloyd Wright, which includes many of Sullivan's ornamental designs of the 1880s and 1890s.[2] This gap in the Art Institute's holdings makes the recent acquisition of this sketch, one of three such drawings found in a book that was once in Sullivan's library, all the more exceptional. The book's owners lent those drawings to the Art Institute for inclusion in the 1987–88 exhibition "Chicago Architecture: 1872–1922," and sold them to the museum a decade later.

The McVickers Theater was the work of Sullivan and his partner, Dankmar Adler, and one of several theaters they designed, the most famous of which is Chicago's landmark Auditorium Building (1886–89).[3] Originally opened in 1857 and rebuilt after the Great Chicago Fire of 1871, the McVickers stood at 25 West Madison Street. In 1883 Adler and Sullivan renovated the building, adding two stories of offices atop; they reconstructed its interior after a fire seven years later. This structure was demolished in 1925 to make way for a newer version, which was itself razed in 1985. Although the McVickers building is gone, we are fortunate to have these examples of its ornament, which demonstrate Sullivan's transition from a more regularized geometric style to one that foreshadows the complex, leafy forms characteristic of his later career.

JOHN ZUKOWSKY

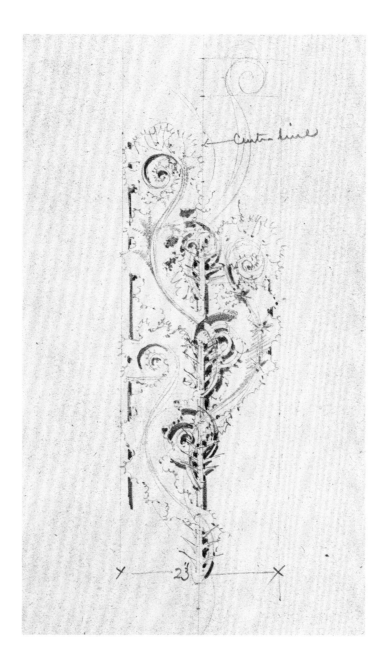

Center line

2"

Section of a Lobby Lantern from the Imperial Hotel, Tokyo

1923

Frank Lloyd Wright
(American; 1867–1959)
Stone, terracotta, unglazed brick, glass; 45 x 64 x 65 cm
(17 3/4 x 25 1/4 x 25 5/8 in.)

THROUGH PRIOR GIFT OF MR. AND MRS. F. M.
FAHRENWALD, 1995.383

Frank Lloyd Wright is, to many, America's greatest architect. Best known as the leader of the Prairie School, he designed, in the early 1900s, homes with rambling, open, horizontal spaces that responded sensitively to the rolling, midwestern landscape of his birth. During a life spanning more than nine decades, Wright shaped American architecture in other ways, from his Usonian homes of the 1930s and 1940s, with their carports and zoned private and public spaces, to his later experiments with curvilinear structures and passive solar energy.

The architect's influence also spanned the Atlantic and Pacific oceans. In Japan, for instance, he designed the famous Imperial Hotel in Tokyo (1923) and a number of other structures.[1] The hotel, a three-story courtyard building, gained immediate renown when its floating foundation and reinforced steel construction helped it survive, with little damage, the Great Kanto earthquake that occurred on September 1, 1923—the very day of its completion ceremony. The building was remodeled to serve the American occupation forces following World War II and was finally demolished in 1968 to make way for a high-rise hotel. Yet, through the efforts of preservationists across the world, its main public spaces were reconstructed in 1976 at the Museum Meiji-Mura, an architectural park near Nagoya that houses Western-influenced buildings.

As part of a larger initiative at the Art Institute, in the early 1990s the museum's Department of Architecture offered the Museum Meiji-Mura some fragments from Wright buildings in exchange for this and other distinctive objects from the Imperial Hotel.[2] To our knowledge, this lantern is the only such piece in an American collection. In his design, Wright placed these lanterns vertically, one above the other, to illuminate corners. The architect employed this arrangement within the hotel's lobby and on the exterior of its main entrance (see fig. 1), using it to dematerialize the structure in a way that resembled his practice of placing windows across corners.

JOHN ZUKOWSKY

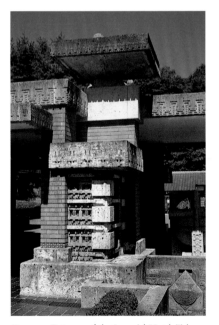

FIGURE 1 Entrance of the Imperial Hotel, Tokyo, reconstructed at the Museum Meiji-Mura. Photo: John Zukowsky.

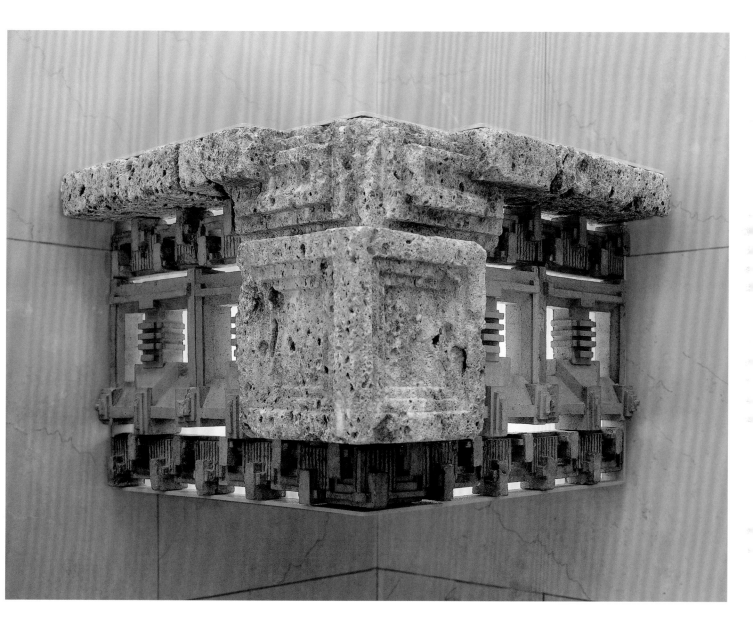

Design Study for a Garden with a Reflecting Pool

c. 1928

Franz Lipp

(American, born Germany; 1897–1996)

Graphite and gouache on tracing paper; approx. 25 x 49.5 cm

(9 7/8 x 19 1/2 in.)

GIFT OF FRANZ LIPP THROUGH THE CHICAGO BOTANIC
GARDEN, 1994.91.7

In the early 1990s, the Art Institute's Department of Architecture, with support from the National Endowment for the Arts, began expanding its collection to include the work of important landscape architects, graphic designers, and industrial designers. One such figure was Franz Lipp. Born in Leipzig and educated at the Gartenbauschule in Potsdam, Lipp immigrated to the United States in 1923, as did many other Germans seeking to escape their country's economic difficulties. He studied at Harvard University's Arnold Arboretum and in 1924 moved to Chicago to work for the noted landscape architect Jens Jensen; he established his own practice four years later. Lipp received his earliest hands-on experience with garden design not through formal training and apprenticeship, however, but while imprisoned in Australia as an enemy alien during World War I.

The designer's hand can still be seen in many institutional, commercial, and private landscapes throughout Chicago and the surrounding region. Some of his works include multidecade contributions to the University of Notre Dame in South Bend, Indiana, and Beloit College in Wisconsin; the Woodfield and Park Forest malls in suburban Chicago; and the gardens at Cantigny in Wheaton, Illinois, the former estate of Colonel Robert R. McCormick, publisher of the *Chicago Tribune*. Lipp's landscape studies, mostly rendered in pencil on paper, are treasures that document his life's work, tracing a career that spanned over six decades. Lipp was a friend to the Art Institute long before he donated his collection of landscape designs to the museum. He served on the advisory committee to the Ryerson and Burnham Libraries and was the subject of the exhibition "Yellowstone Park: A Photographic Interpretation by Franz Lipp," on display at the Art Institute in the summer of 1951.

JOHN ZUKOWSKY

Interior Perspective View of the United Airlines Terminal, O'Hare International Airport, Chicago

1985

Helmut Jahn

(American, born Germany, 1940)

Delineated by Rael Slutsky, Murphy Jahn Architects

Graphite and colored pencil on paper; 44.5 x 62.5 cm
(17 1/2 x 24 5/8 in.)

GIFT OF HELMUT JAHN, 2001.532.1–2

Helmut Jahn is one of today's so-called "starchitects," having achieved international acclaim for projects stretching from Bangkok and Shanghai to Berlin and Munich. Most recently, his Sony Center on Berlin's Potsdamer Platz (2000) became the centerpiece of the reunified city, situated in what was, until 1989, the dreaded no-man's land between West Berlin's free-market zone and the socialist capital of East Berlin.¹ Jahn, himself German, was born in Nuremberg and attended the Technische Hochschule in Munich, graduating in 1965. He then came to Chicago for further study at the Illinois Institute of Technology, where, in 1967, he was hired by Gene Summers of C. F. Murphy Associates to assist in the design of McCormick Place, the city's monumental convention center on Lake Michigan. When Summers left the firm in 1973, Jahn became its top designer, gaining a reputation as the creator of bold, innovative structures that nevertheless recall buildings of the past. In Chicago these include an Art Deco–like addition to the similarly styled Chicago Board of Trade (1980); the streamlined Northwestern Tower (1987); and the controversial State of Illinois Center (now the James R. Thompson Center) of 1985, which he graced with a sweeping interior space that was inspired, in part, by traditionally domed state capitol buildings.

For the United Airlines Terminal at Chicago's O'Hare International Airport, Jahn provided his client with a striking, steel-and-glass monument that suggests the grand transportation spaces of earlier eras, particularly the great railroad stations of the nineteenth century. While evoking past architectural forms in his plan for the terminal, Jahn also embraced the present. He established a remote concourse for additional gates and connected both the main and remote concourses with an underground people mover; above this he created enough taxiing space for the airline's wide-body planes to safely circulate between the two parts of the terminal. The architect also designed the dramatic subway station that connects the airport to Chicago's Loop business district and outlying neighborhoods.

JOHN ZUKOWSKY

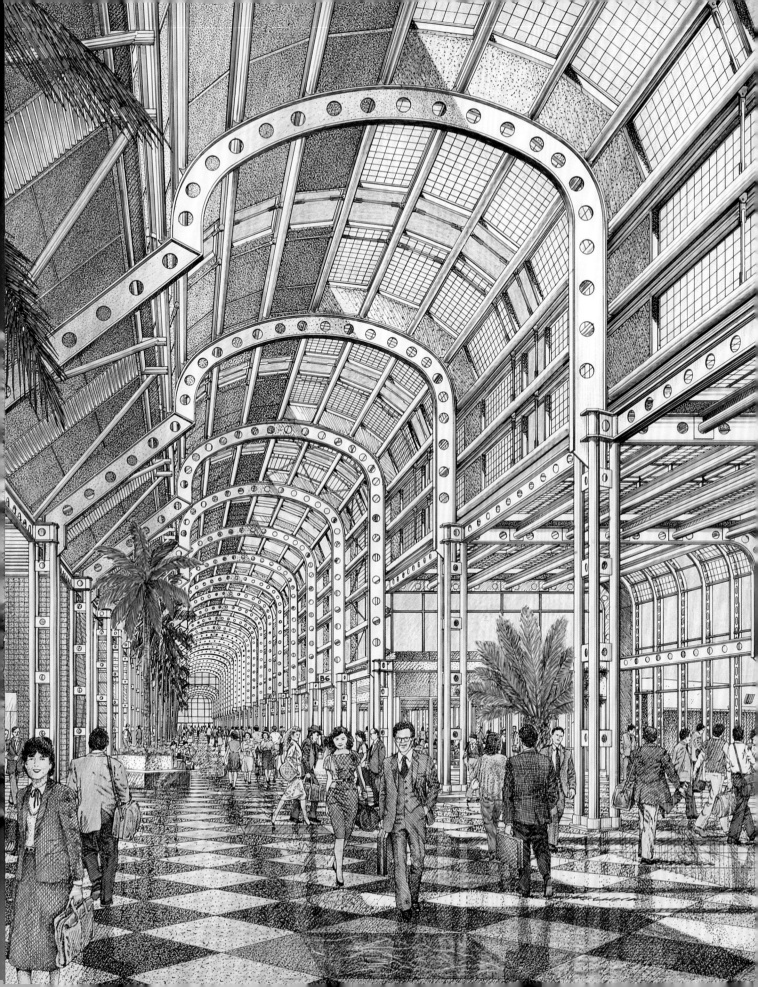

Yamantaka

12th century

China, Yunnan province
Dali kingdom (A.D. 937–1253)

Cast iron; h. 29.5 cm (11 in.)

KATE S. BUCKINGHAM ENDOWMENT, 1999.374

His six legs propped on a crouching buffalo, the wrathful Buddhist deity Yamantaka, conqueror of death (literally, "he who puts death to death"), bristles with aggressive fury. Backed by a single halo of tightly coiled and flaming hair, Yamantaka's six heads each feature a forehead protuberance (*urna*), bulbous eyes, a scowling, fanged mouth, and a diadem of skulls. (A prong behind these six heads likely dovetailed into a larger halo of flames, now lost.) Bands of snakes encircle the figure's upper arms, wrists, and ankles; a long band, draped around his collar and over one shoulder, crosses his stomach as a garland of decapitated heads. Each of his six hands grasps a weapon or implement: a skull bowl (*kapala*), pronged thunderbolt scepter (*vajra*), bow, arrow, sword, and noose. The hand that holds the noose also raises one finger in a sacred gesture of admonition (*tarjani mudra*). Together, these aggressive attributes denote resistance to human failings and misdeeds: ignorance, evil, and wrongdoing.[1]

Like other fearsome deities that were envisioned to subdue obstacles to enlightenment, Yamantaka personifies the complex doctrines of Esoteric or Tantric Buddhism, which originated in northeastern India.[2] By the end of the first millennium A.D., devotees carried their powerful teachings, together with an impressive pantheon of icons, over the Himalayan ranges of present-day Nepal and across the vast Tibetan plateau to China's remote southwestern frontier—present-day Yunnan province. Portable and durable, small, cast-metal sculptures were transported along these far-reaching pilgrimage routes and donated to regional monasteries, where they may have inspired reinterpretations such as this.

The nationality of the artist who cast this rare iron figure may only be surmised. Stylistically, it bears striking resemblance to a remarkable find in western Yunnan: a gilt-bronze image of a terrifying deity who, like Yamantaka, represents a wrathful king of esoteric knowledge (*vidyaraja*). In 1978, while restoring the multistoried Qianxun Pagoda—the largest of three brick pagodas surviving from the Chongshan monastery—archaeologists discovered that figure among more than one hundred sculptures, most cast of bronze or gold and concealed inside two wood pillars beneath the roof. Textual records date the consecration of the Qianxun Pagoda treasure to the twelfth century, when the independent kingdom of Dali ruled the area.[3] Bordered by present-day Tibet, Myanmar (Burma), and Thailand, Dali was an ethnic and strategic crossroads for Buddhist pilgrims as well as local artists, most notably a painter whose Chinese name is recorded as Zhang Shengwen. Zhang's renowned *Long Scroll of Buddhist Images* (1173–76) in the National Palace Museum, Taipei, includes a fierce portrayal of Yamantaka that reinforces the Dali kingdom provenance of this sculpture.[4]

ELINOR PEARLSTEIN

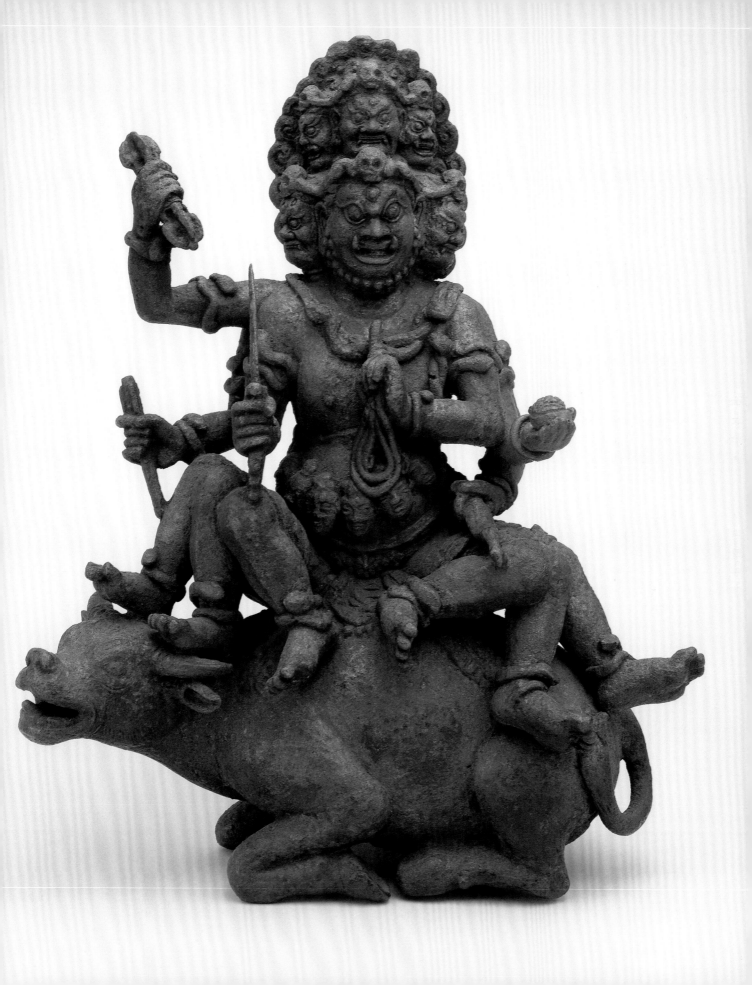

Mahamayuri Vidyaraja

11th or 12th century
China, Liao dynasty (916–1125)

Ink and colors on cotton; 142 x 89 cm (55 7/8 x 35 in.)

KATE S. BUCKINGHAM ENDOWMENT, 2002.367

This rare painting depicts Mahamayuri Vidyaraja, a Buddhist deity first worshipped in China during the late Six Dynasties period (420–589). His cult endured for over six hundred years, through the subsequent Tang, Liao, and Song dynasties. The special skill of this god, who was known in China as Kongqiao mingwang, or the Peacock Wisdom King, was preventing and curing injuries caused by poison. Here he appears riding a peacock and holding different attributes in each of his six hands: the *vajra* (stylized thunderbolt), a bow and arrow, a sword, a book, a lance, and the *ghanta* (bell). The *vajra* and *ghanta* symbolize wisdom and compassion, and the unity of the spiritual and material worlds. The sword, lance, and bow and arrow are all weapons to combat evil. The peacock may indicate that the deity is an emanation of the historical Buddha Shakyamuni, who in an earlier life was reincarnated as a peacock.

The deity is described in the *Mahamayuri Sutra*, a collection of Buddhist precepts first translated from Sanskrit into Chinese during the Liang dynasty (502–557). The text tells of a powerful spell that can be used to invoke the deity and dispel the effects of poison. The sutra also includes the story of the monk Svati, who was bitten by a venomous snake and saved himself by chanting the Mahamayuri spell; a scene from this tale appears at the bottom of the scroll. It is likely that the book held in the deity's upper-left hand is the *Mahamayuri Sutra*. The painting would have been used in a Buddhist temple or private shrine, where it functioned as a powerful protective icon against calamities.

The Liao emperors who ruled northern China during the tenth and eleventh centuries were patrons of the Huayan (Flower Garland) school of Buddhism, for whose adherents Mahamayuri Vidyaraja had a special attraction. While the deity's cult did not last in China beyond the late Song period in the twelfth and thirteenth centuries, it was transmitted to Japan and survives to this day among the Kegon (Flower Garland) and Shingon (Mantra or "True Word") schools. Many images of the deity exist in Japan in both painting and sculpture.

The style of the painting, with its clear composition and bold coloring, most likely derives from a now lost original made during the Tang dynasty. The realistic rendering of both the figure and the bird resembles surviving paintings of the Northern Song dynasty (960–1126) and suggests that the work can be dated to the eleventh or twelfth century.[1]

STEPHEN LITTLE

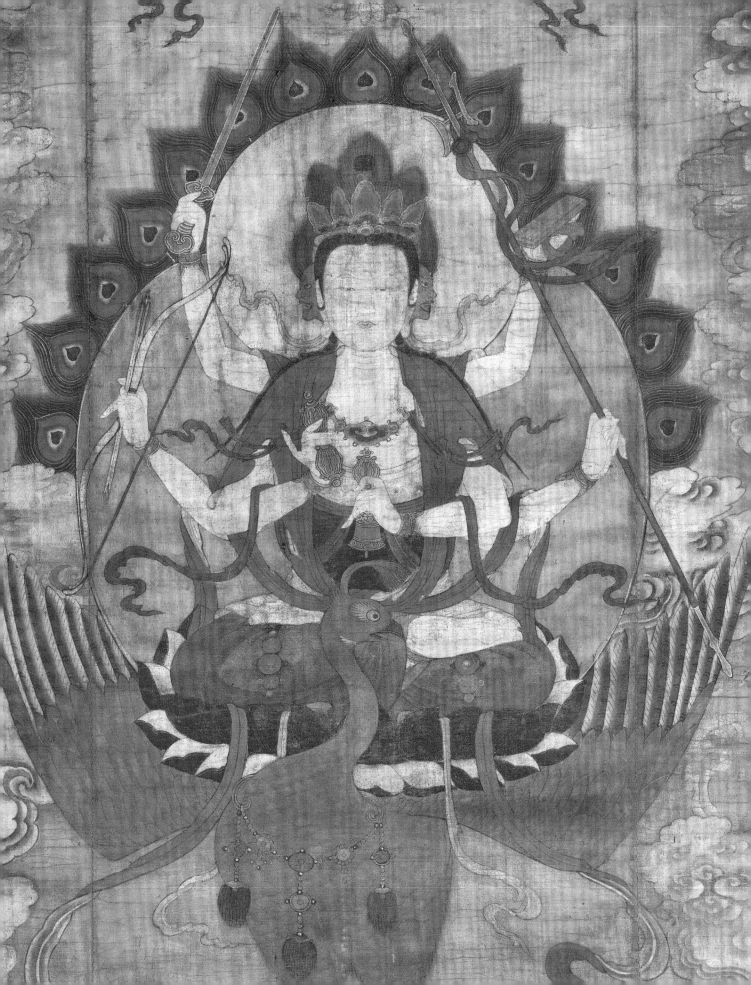

Poetic Thoughts in a Forest Pavilion

c. 1371

Ming dynasty (1368–1644)

Ni Zan

(Chinese; 1306–1374)

Hanging scroll; ink on paper; 124 x 50.5 cm (48 7/8 x 19 7/8 in.)

KATE S. BUCKINGHAM ENDOWMENT FUND; RESTRICTED GIFT OF THE E. RHODES AND LEONA B. CARPENTER FOUNDATION (1996.432)

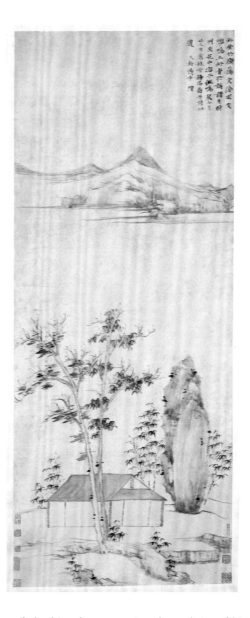

A native of Wuxi in Jiangsu province, Ni Zan lived during the brutal Mongol occupation of China (Yuan dynasty, 1260–1368). Only at the end of his life did he witness the reestablishment of native Chinese rule under the Ming dynasty. Ni received a classical education and the training to be a scholar-official. While still a young man, however, his father and older brother died, and he became the head of his land-owning family. Living off enormous wealth, he became famous for his calligraphy, painting, and poetry.

In this landscape we see a riverbank with trees, a pavilion, and a tall garden stone in the foreground; a river in the middle distance; and a range of desolate hills in the background. The composition is elegant and deceptively simple, with a refined, subtle handling of ink. Ni presents a pristine view of a world reduced to pure essences. The Chinese regarded these landscapes as self-portraits of the artist; in the utterly spare composition and deft pacing of the brushwork, viewers saw something of Ni's moral integrity and astringent, elusive personality.

The scroll bears a poem written in Ni's elegant calligraphy. Here he compares the music of the *qin* zither to good government, which was noticeably absent in his own day. The poem speaks of Master Fu, a district supervisor and qin master of the late sixth century B.C. Fu, a contemporary of Confucius, ruled through a kind of "nonaction"—merely by sitting in his house and playing the zither, he kept his district completely at peace. Ni ends by bitterly contrasting the realities of his own time with that of Master Fu. Both poem and landscape resonate with the image of the qin, reflecting Ni's fame as a player and composer of qin music. The poem describes the scholars who visit the house in the painting, where they listen to the qin and chant poetry. For Ni and his contemporaries, the idea that music could rectify a chaotic political landscape was a joke. Viewed in this light, the seemingly bland landscape is imbued with an intense melancholy and irony.

STEPHEN LITTLE

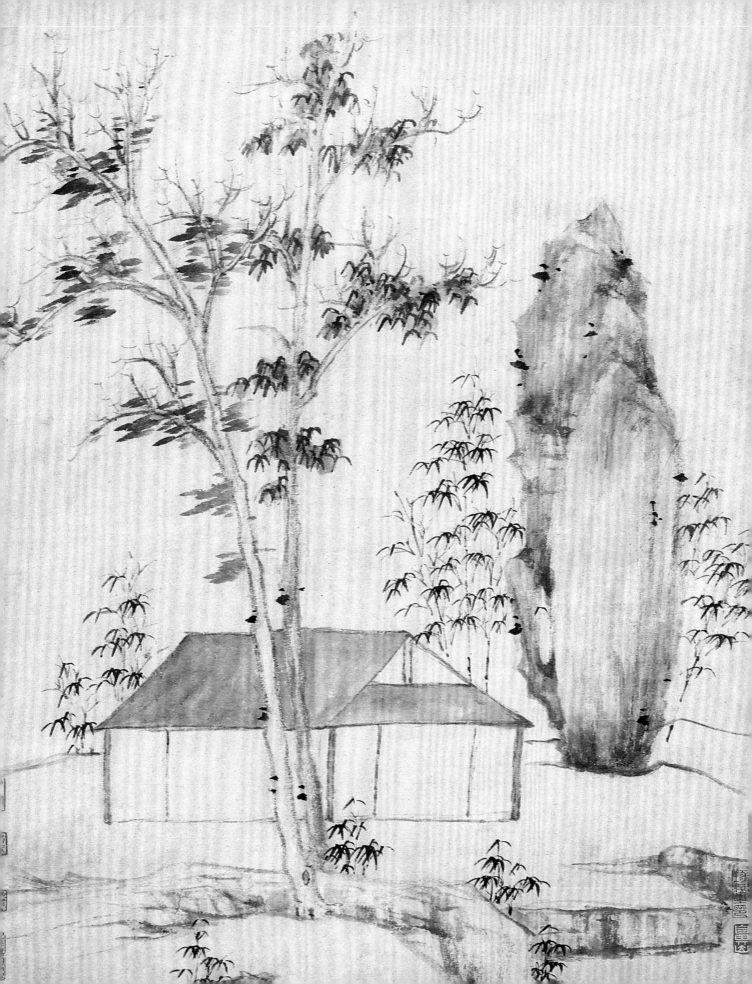

Willow Bridge and Waterwheel

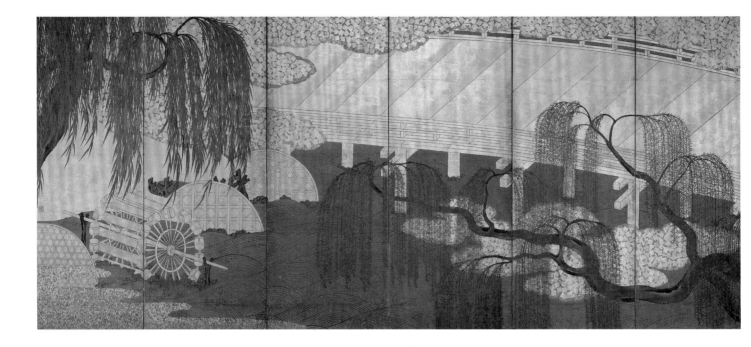

c. 1650
Edo period (1615–1868)

Hasegawa Sōya
(Japanese; 1590–1667)
Pair of six-panel screens; ink, color, gold and silver leaf on paper;
each screen 375 x 171 cm (147 3/4 x 67 3/4 in.)

KATE S. BUCKINGHAM AND FREDERICK W. RENSHAW
ENDOWMENTS, 2002.365.1–2

Containing an impressive quantity of precious materials employed in a meticulous way, this pair of screens exhibits the highest level of artistry and presents a striking combination of strong colors and varying textures. The artist, Hasegawa Sōya, not only used gold and silver in several forms—as leaf, powder, and cut squares—but also applied the leaf diagonally to accentuate the curve of the bridge, an innovative approach rarely seen on other screens.[1] He laid on the malachite green of the willow leaves so thickly that they appear in relief; in several locations he painted gold over *gofun*, an oyster-shell-white pigment, to produce a similarly subtle, raised effect.

The bridge, a quintessential subject of Edo-period folding screens, spans the Uji River, which flows between Kyoto and Osaka and has long been a location of strate-

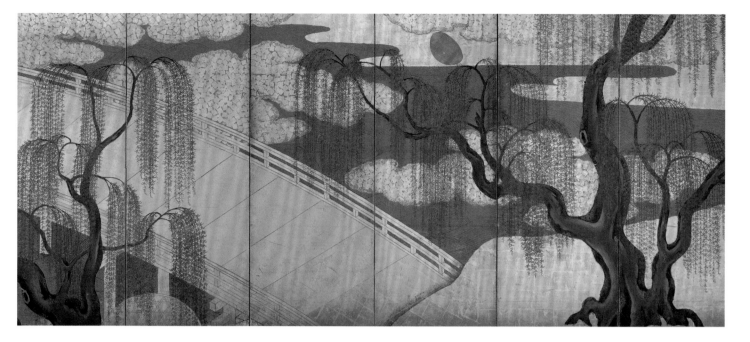

gic military importance and religious significance. The imperial family regarded the area as a place of great charm and spiritual power; records indicate that paintings of Uji were done for the Imperial Palace as early as the ninth century. Several aristocratic poems hail the beauty of the place, and it was also the location of the last section of Murasaki Shikibu's famous eleventh-century novel about courtly life, the *Tale of Genji*. The celebrated Byōdō-in Temple was built just beside the bridge later in the same century. Also well known was the Uji Battle, which was fought there between the Taira and Minamoto clans during the civil war of the twelfth century. While Uji was represented in a number of ways earlier on, by the Edo period specific images were used to evoke the location. Visible here are rock-filled baskets, a curved bridge, trail-

ing mist, the moon, a waterwheel, willows, and undulating waves—all elements that were originally drawn from classical poetry and that came to define Uji.

Luxurious screens such as this one could only have been commissioned by the very upper echelons of society. This particular subject matter would have appealed to nobles, military warlords, and wealthy merchants alike, given the nostalgia that Uji evoked for the courtly elegance of Japan's past. The willow trees are shown with the short, new growth of spring on the right and the longer leaves of summer on the far left, making these screens appropriate for use at banquets or other special events during those seasons.

JANICE KATZ

Resting in the Shade

c. 1933
Shōwa period (1926–1989)

Yamakawa Shūhō
(Japanese; 1898–1944)
Two-panel screen; ink and colors on silk; 182 x 166 cm
(71 5/8 x 65 3/8 in.)

KATE S. BUCKINGHAM ENDOWMENT, 2000.475

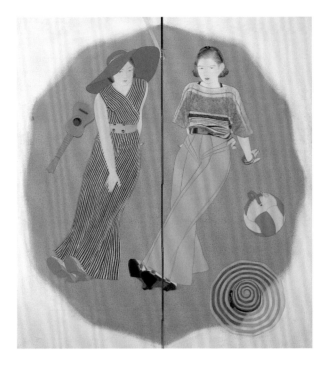

This screen created quite a stir when it was first shown at the government-sponsored Teiten Exhibition in 1933. The two women, somewhat antagonistically, stare straight out at the viewer as they lay on the beach. The one on the right, in particular, with her heavy lids and pursed lips, makes us feel as if we are disturbing her privacy. Their strong self-confidence, combined with modish Western attire and short haircuts, marks the pair as "modern girls" (*modan gaaru* or *moga*) who follow the vicissitudes of fashion and spend some of their ample leisure time relaxing by the seashore. These are not the *bijin* (beautiful women) of Edo-period woodblock prints, whose eyes rarely meet those of the viewer. Their flared pant legs, wide-brimmed hats, and colorful sandals are outward declarations of an inward independence.

Yamakawa Shūhō employed stripes as an overall theme for his composition, using them to render his subjects' hair and accentuate their trendy clothing and accessories. The artist painted white grains of sand in low relief using *gofun*, a traditional oyster-shell-white pigment. He also chose to adopt a very severe point of view, which caused one critic to complain that the women appeared to be standing upright rather than reclining.[1] However, when the screen is folded slightly and a viewer stands before it, the perspective suddenly makes sense, with one woman stretched out on either side of the fold. In this way, the artist experimented with the use of space. He also played with shadow and light, enclosing the two women within a circle of shade cast by an unseen umbrella, the base of which is visible at top center.

In technique as well as subject matter, this screen is representative of *Nihonga* painting of the period between the Russo-Japanese War (1904–05) and World War II. *Resting in the Shade* is the finest of the Art Institute's growing collection of *Nihonga* from the 1920s and 1930s.[2] *Nihonga*, which used age-old materials and formats, was defined in opposition to *yōga*, or Western-style watercolor and oil painting. Works such as this one, which combined traditional techniques and modern subject matter, were particularly effective at illustrating the redefinition of traditional values that Japanese society was undergoing at the time.

JANICE KATZ

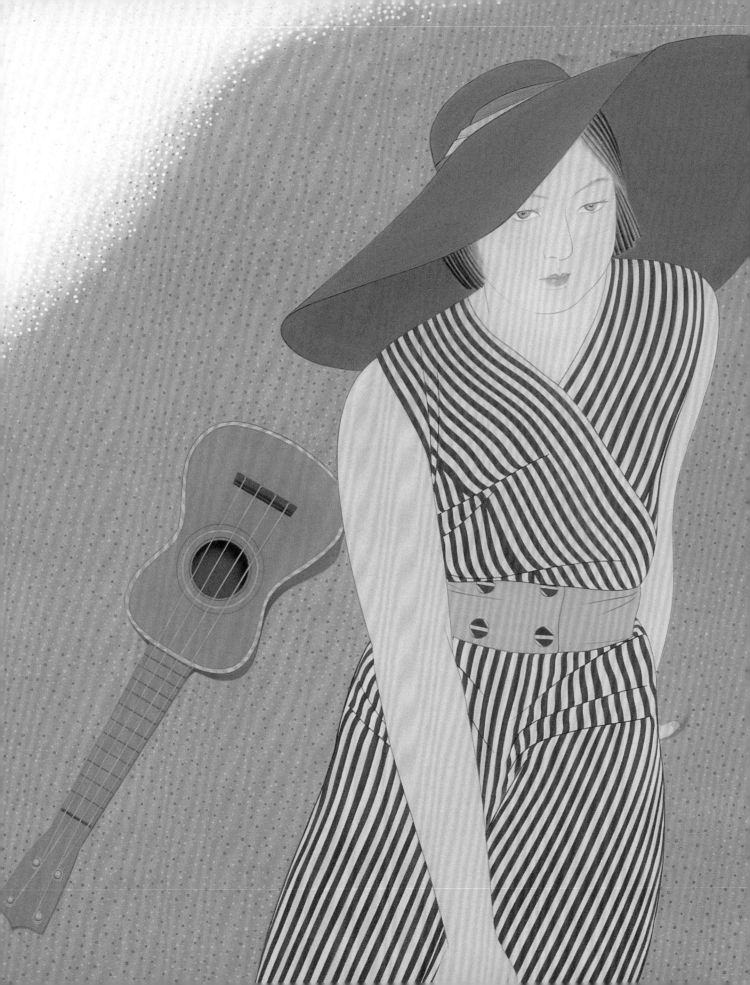

Vase

c. 1950

Shōwa period (1926–1989)

Hamada Shōji

(Japanese; 1894–1978)

Stoneware; 35.8 x 31.5 cm (14 1/8 x 121 3/8 in.)

RICE FOUNDATION FUND; BERTHA E. BROWN ENDOWMENT,
2000.87

One of Hamada Shōji's maxims was "body and clothes should go together," a reference to the necessary resonance between a pot's clay form and its glazed decoration. Such a phrase sums up the beauty of this large vase. To create it, Hamada attached ribs of clay to the stoneware body, forming registers that divide the form into sections for decoration. He then dipped the entire piece into a vat of glaze, which imparted a rich, complex color that has pooled on the ribs. The artist was a master at preparing unusual glazes and meticulously refining them until they were of just the right consistency. In the glaze used here, he likely mixed a green variety with a caramel-colored one known as *ameyū*. He made the organic, leaflike decoration by applying wax with his fingers; when fired, the wax melted to reveal the bare clay below, as clothes reveal a body.

Hamada was one of the pioneers of the Japanese *Mingei* (folk craft) movement, which infused traditional arts with a new burst of individual and personal expression. After befriending the English ceramist and writer Bernard Leach, he traveled to Britain, where in 1920 he helped Leach set up a kiln at St. Ives, Cornwall, a well-known artist's colony that was then somewhat past its heydey. Having gotten the English countryside into his bones, the Tokyo native set up a permanent studio in the village of Mashiko in 1930, after returning to his home country. Hamada chose this location in part because of the unique quality of the local clay, which requires extensive processing and wedging but produces very strong ceramics. In 1995 Hamada was honored as a Living National Treasure.

The potter played with this type of registration-line design, loosely reminiscent of roof tiles, throughout his career. The lines could be rendered differently for a variety of effects: sometimes Hamada drew them with glaze; at others he incised them into the body; and on still other occasions he used ribs of clay to make raised lines like those seen on this vase. This is one of the largest pieces known with such decoration and would appear to be the culmination of his experiments with that style. It is also the most significant piece of Hamada's work to enter the Art Institute's collection thus far, in terms of both its size and its important place in his artistic development.

JANICE KATZ

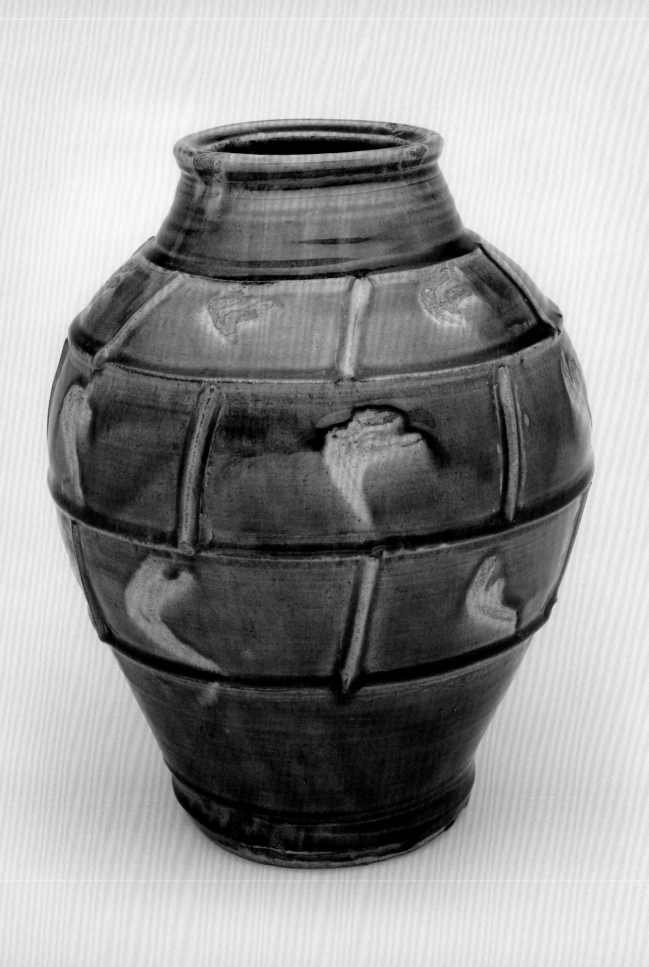

Hindu Goddess, Possibly Uma

10th century, Dông Duong period

Vietnam, Cham kingdom (A.D. 192–1471)

Bronze; h. 74.5 cm (29 3/8 in.)

KATE S. BUCKINGHAM ENDOWMENT, 1999.248

It is believed that the earliest Chams, whose kingdom occupied the central coastal region of present-day Vietnam, originally migrated from islands to the south. Arriving in the second century A.D., they brought with them the culture of India, which included Hinduism, Sanskrit, temple architecture, and sculpture. By the late ninth century, Cham civilization had organized itself on the Hindu model of kingship and religious practice, in which royal ceremonies were used to invoke the god Shiva's protection of land and lineage. Indeed, the worship of Shiva dominated the Chams' spirituality, and its imagery infused their art.[1]

The flowering of Cham cultural achievement began during the tenth century and was characterized by a syncretic blend of outside influences and artistic originality. In addition to vast architectural complexes such as Dông Duong, the art of the Chams included small, freestanding sculptures such as the Art Institute's elegant goddess, who is very likely Uma, consort of Shiva.[2] She is connected to her land of origin by her distinctive physiognomy—large, wide-set eyes, broad nostrils, and abundant facial hair, such as a single eyebrow and a distinctive hairline that connects with sideburns. In addition to a towering coiffure of herringbone braids, the goddess's face would have been enhanced by a gemstone on her forehead and detachable earrings in her elongated, pierced lobes, now broken. The shape of her body also reveals a uniquely Cham aesthetic. Below her full breasts, two incised lines suggest the rolls of a prosperous, if narrow, midriff. The figure's slim hips and long legs are sheathed in a single, tightly wrapped sarong, the front fold of which bears a rich, foliate pattern.

Both the sculpture's completely frontal stance and the absence of detail on its back suggest that it was designed to be displayed in a niche. It lacks its pedestal, however, which might have offered inscriptions or stylistic clues linking it to a particular shrine or architectural setting. What remains is its pure beauty. The high copper content of the bronze alloy gives the goddess a jadelike luster that is marred only by a rusted interior support that pokes through at her shoulders, elbows, and wrists. Her lovely smile helps establish her tenth-century origins.[3]

BETTY SEID

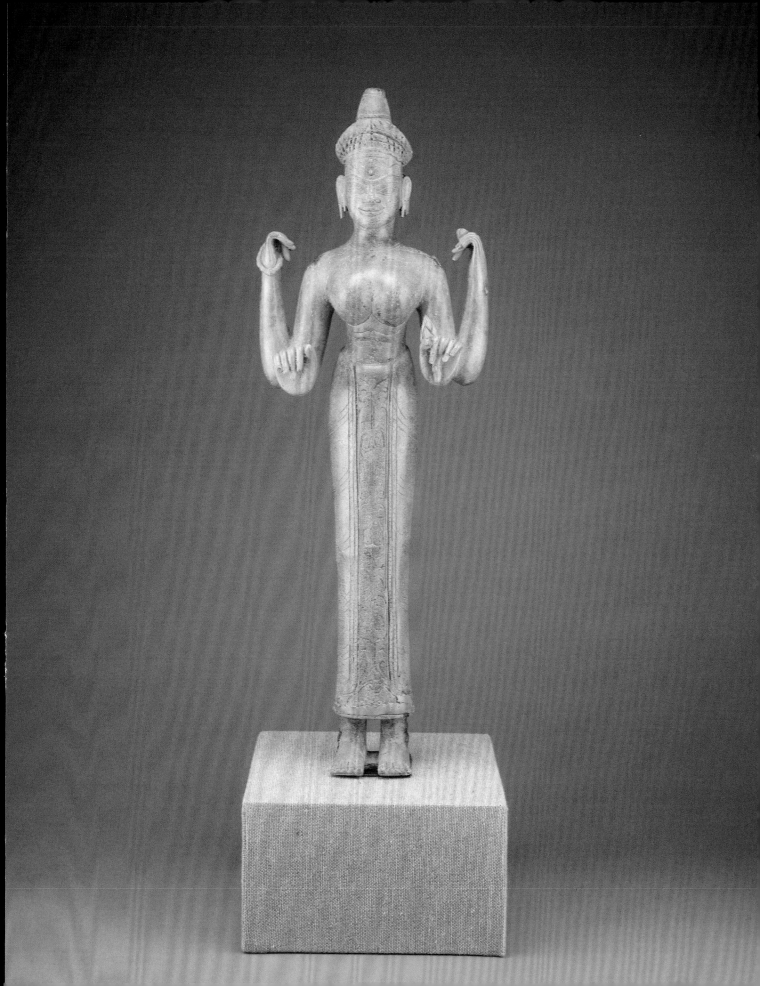

An Illustration to the "Baburnama": Kichik Khwaja Wounded during Babur's Attack on Qalat

c. 1590

India, Mughal
Painted by Kanha and Mansur

Pigment and gold on paper; image 24.4 x 13.0 cm (9 5/8 x 5 1/8 in.),
sheet 31.7 x 21.7 cm (12 5/8 x 8 1/2 in.)
Inscribed: *tarh-I-kanha, amal-I mansur naqqash*
(outlined by Kanha, the work of Mansur Naqqash)

KATE S. BUCKINGHAM ENDOWMENT, 1995.242

At the age of eleven, Zahir ad-Din Muhammad Babur (r. 1526–1530) inherited the throne of Ferghana in Andijan (now Uzbekistan), "a kingdom in Central Asia that was smaller than his ambitions."[1] Babur kept a diary in which he recorded his marches and battles, and described the flora and fauna that he encountered on his ferocious campaigns to enlarge his empire. He included personal anecdotes, family genealogies, and his own verses, showing a depth of observation that reveals a romantic poet within the armor of a soldier.

Babur set out to conquer Hindustan (India) and in 1526 founded the Mughal empire. Two years later he decided to expand his diary into a full narrative memoir, the *Baburnama*, which was written in his native language, Chaghatai Turki.[2] Two generations later, his grandson, the Mughal emperor Akbar (r. 1556–1605), commissioned a translation into Persian, the language of his court. The project was completed in 1589, and within a year the first illustrated edition was produced by Akbar's imperial workshop.[3] Akbar himself chose the episodes and directly oversaw the work, which was accomplished by an army of artisans that ranged from paper makers to pigment grinders, brush makers to gilders. With as many as one hundred people contributing to its production, a single painting took about fifty days to complete.[4]

In addition to its narrative function, the *Baburnama* is a valuable historical document of weaponry and warfare. Each illustration conforms strictly to the text, as does this painting, which represents Babur's 1505 attack on the city of Qalat-i-ghilzai, between Kandahar and Kabul. Designers divided the work into two bands of activity that were meant to suggest perspective: the emperor's army (in carefully delineated tunics, quilted protective garments, and domed helmets) presses its assault in the foreground (below), while the besieged send volleys of arrows and gunfire from their pink stone fortress in the distance (above). Another attempt to achieve dimensional effects can be seen in the slight shading of the cylindrical towers and the smaller size of the figures on the ramparts.[5] In contrast to the work's generally crisp detailing, artists adopted a soft watercolor technique for the musket smoke and employed a varied pastel palette, characteristic of Mughal painting, on the city's gated walls. A spiraling composition draws attention to the hero, Kichik Khwaja, who is carried from the field, his right eye bleeding from a wound that will soon kill him.[6] Although several of his fellow soldiers hold their shields above their heads for protection, one unlucky comrade is about to be struck by a stone hurled from atop Qalat's central tower.

BETTY SEID

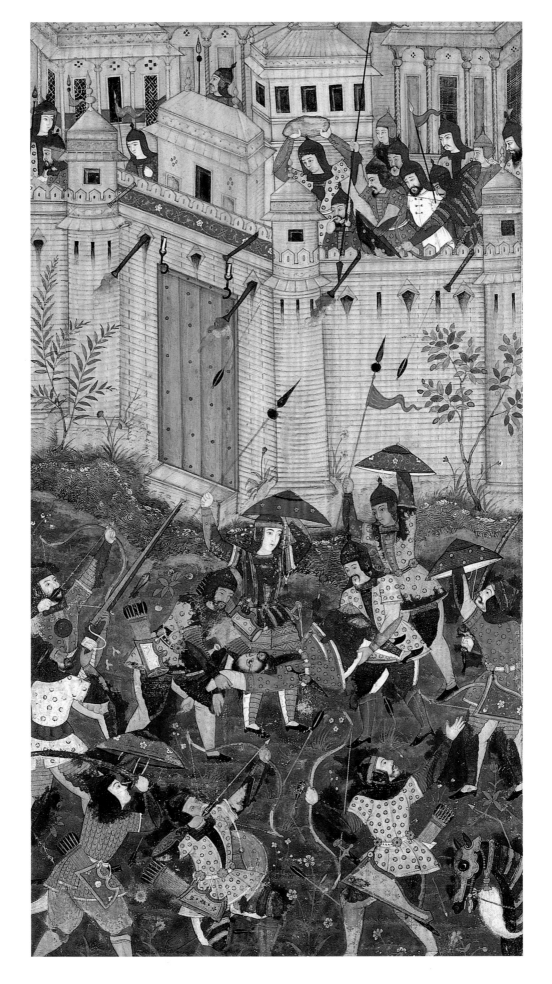

Saint Anthony Abbot

c. 1440–41

Fra Angelico (Guido di Piero da Mugello)
(Italian; 1395/1400–1455)
Tempera on panel; 39.4 x 14 cm (15 ½ x 5 ½ in.)

BEQUEST OF ELIZABETH IGLEHART BLAIR, 2001.329

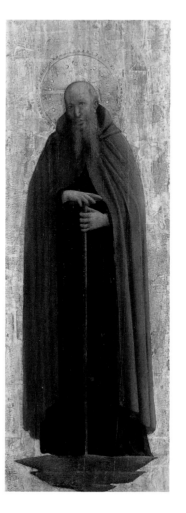

A member of the Dominican order, Fra Angelico rose from the rank of manuscript illuminator to become one of the dominant forces in early-fifteenth-century Italian painting, commanding the most substantial and respected atelier in Florence. By studying works of the innovative Florentine master Masaccio, which were distinguished by their naturalism and gravity, Fra Angelico developed a monumental narrative style that he employed in major altarpieces and important fresco commissions. Foremost among these was the extensive decorative program he undertook for San Marco, the religious community in which he was cloistered; this scheme included an altarpiece (c. 1440–41) for its church and more than fifty frescoes (c. 1444–50) for its convent. Cosimo (the Elder) de' Medici and his brother Lorenzo provided the financial resources for this ambitious project, which the friar-painter realized with the aid of myriad assistants. Cosimo, the de facto leader of Florence and the man largely responsible for amassing his family's great wealth, lived near the church and maintained a penitential cell there.

The Art Institute's *Saint Anthony Abbot* was, almost certainly, once part of the grand altarpiece that Cosimo commissioned for San Marco's high altar. Dismantled in the eighteenth century, this work comprised a large, central panel representing the *Virgin and Child with Saints* (now in the Museo di San Marco, Florence); eight narrative panels depicting the lives of Saint Cosmas and Saint Damian; and ten small pilasters devoted to individual saints, including Anthony Abbot. This image of the saint, with its attenuated dimensions, would probably have been positioned to the right of the central panel and installed vertically along with four similar works; this presentation would have been reminiscent of the jamb figures on the doorways of a Gothic church. In these respects the painting retains its connections to the mystical, International Gothic tradition of fourteenth-century art, in which insubstantial figures were placed hierarchically within an abstracted space to suggest a spiritual realm. Despite the figure's delicacy and refinement, the picture as a whole has a monumental quality appropriate to the eminent saint, a fourth-century ascetic who is credited with the founding of Western monasticism.

LARRY J. FEINBERG

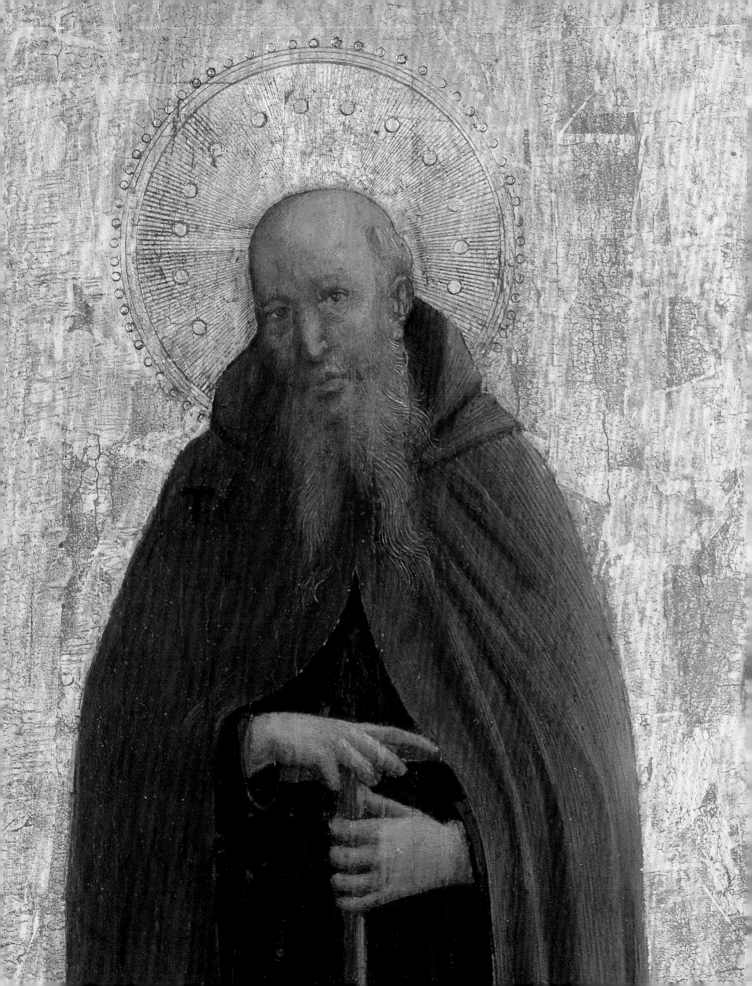

The Death of Saint Peter Martyr

c. 1530–35

Giovanni Girolamo Savoldo
(Italian; act. 1508–c. 1550)

Oil on canvas; 115.3 x 141 cm (45 5/16 x 55 1/2 in.)

Inscribed: *CR* (for *Credo in Dio* [I believe in God],
on a rock at lower left)

LACY ARMOUR ENDOWMENT, 2001.330

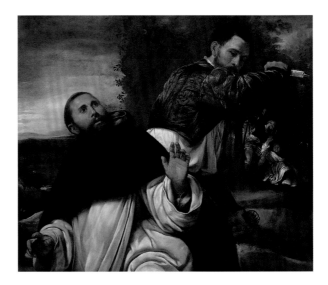

In recent years Giovanni Girolamo Savoldo has come to be recognized as a major master of the Italian Renaissance. Born and presumably trained in Brescia, he became familiar with both the literal realism of local Lombard painting and the most progressive artistic trends in nearby Venice. Through his Flemish contacts, Savoldo also acquainted himself with the subtle effects of light achieved in Netherlandish pictures, particularly in nocturnal scenes. Drawing on these various influences, he created a darkly poetic style, and was admired for his portrayal of reflective psychological states and evocative landscapes, and for his tour-de-force renderings of luminous garments.

This painting, in its high drama and bold composition, represents one of Savoldo's most ambitious responses to the works of Titian. Dating from Savoldo's mature period in Venice, the work depicts the murder of Saint Peter Martyr, a Verona-born, thirteenth-century Dominican friar who devoted himself to reconverting to Catholicism the Cathar heretics in the Veneto-Lombard region of Italy. Enraged by his activities, a group of Cathars ambushed him on the road between Como and Milan. In the midst of the attack, Peter reportedly wrote in the dirt beneath him "I believe in God." Savoldo rep-

resents the assassin, Caino, about to strike the friar with his dagger; his other hand already grasps his sword, with which he will presumably deliver the fatal blows. The Cathar's vibrant red jacket conveys the passion and anger of his act, otherwise veiled by his curiously introspective countenance. The saint's vulnerability and resignation are eloquently communicated by his left hand, which is isolated at the very center of the composition. In the right background, a second Cathar assaults another Dominican friar. The ominous, twilit sky, visible behind Peter's head, fittingly complements the narrative.

Partly due to its matter-of-fact naturalism and attention to texture and detail, common traits of Lombard painting, *The Death of Saint Peter Martyr* has an assertive, material presence that is unusual for an early-sixteenth-century Italian canvas. In fact, the work's insistent physicality and life-size, half-length figures approximate those of paintings conceived fifty years later by Michelangelo Merisi da Caravaggio, who, as a native of Lombardy, would have studied paintings such as this in his youth.

LARRY J. FEINBERG

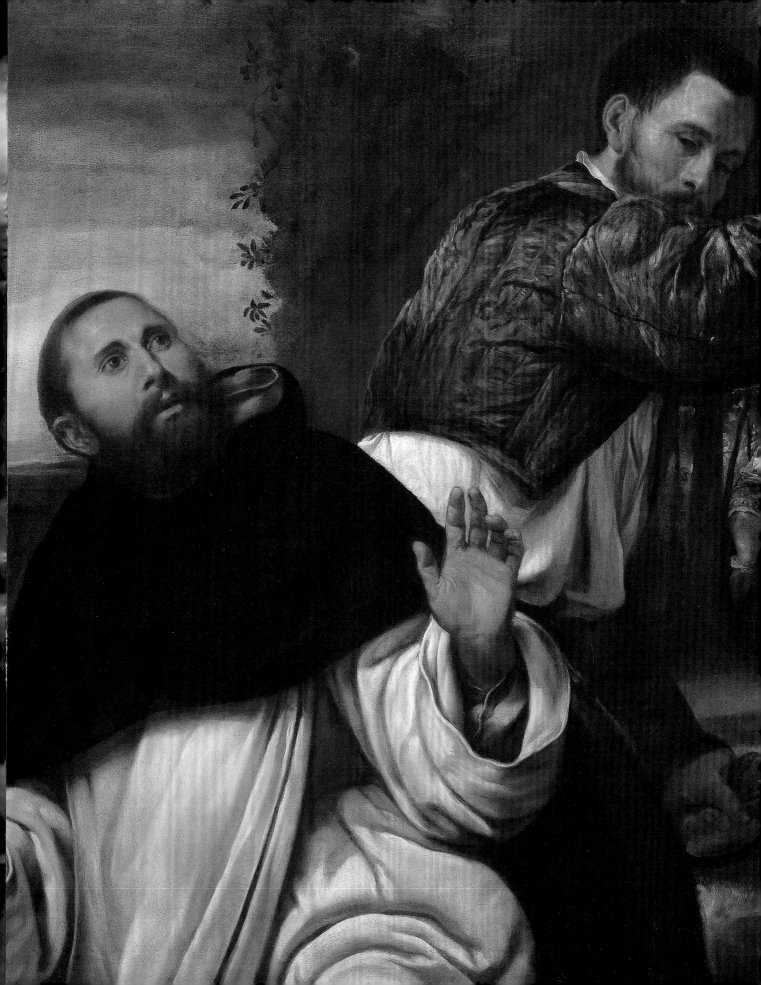

Saint Peter Penitent

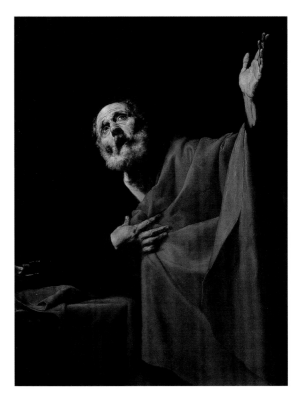

c. 1628/1632

Jusepe de Ribera
(Spanish; 1591–1652)
Oil on canvas; 126 x 97 cm (49 3/4 x 38 1/4 in.)
Inscribed: *Jusepe de Rib / español. F.* (at lower left)

MRS. GOLDABELLE MACOMB FINN FUND, WITH ADDITIONAL
SUPPORT FROM FRIENDS OF THE EUROPEAN PAINTING
DEPARTMENT, MRS. JAMES W. ALSDORF, MRS. EDWARD
MCCORMICK BLAIR, MR. AND MRS. GERALD GIDWITZ,
JOSEPHINE AND JOHN J. LOUIS, JR., THE OTTO L. AND
HAZEL T. RHOADES FUND AND MRS. GEORGE B. YOUNG;
L. L. A. S. COBURN ENDOWMENT, 1993.60

Jusepe de Ribera's career demonstrates the international character of Baroque painting and especially of the realist tradition founded on the work of Michelangelo Merisi da Caravaggio. Born in Spain, Ribera traveled to Italy as a young man. In Rome from about 1613 to 1616, he developed a style that was much influenced by the work of Caravaggio (who had died in 1610) and by his Italian, French, and Netherlandish followers. In the decade after Caravaggio's death, his followers continued to explore his innovative approach, which included dramatic light effects and direct narratives enacted by figures drawn from the humbler ranks of contemporary society.

In 1616 Ribera settled in Naples, at that time ruled by the Spanish crown but possessor of a proud and cosmopolitan history. There he set up a flourishing practice, chiefly as a painter of altarpieces and other religious subjects. Three-quarter length, portraitlike representations of saints were an important part of his production; they evidently suited the sober, Counter-Reformation spirituality of his Spanish and Neapolitan patrons. *Saint Peter Penitent* is remarkable within this larger group of works, not only as a forceful single figure but also because of its implication of spiritual dialogue. The apostle, identified by the massive key on the ledge at left, gazes upward with an awestruck, anxious air, one hand open in supplication and the other pressed to his chest in acknowledgment of weakness. In depicting Peter's repentance, Ribera referred to the saint's denial of Christ, recounted toward the end of all four Gospels. When Christ was brought before the authorities for trial, Peter mingled with the crowd, but when he was recognized he responded fearfully, on three occasions insisting that he did not know Christ. Here, legible gestures and the brilliantly observed features of an ordinary old man dramatize an encounter with the divine, and link this painting to Ribera's larger narratives such as *Saint Jerome and the Angel of Judgement* (1626) in the Gallerie Nazionale di Capodimonte, Naples, and *Jacob and His Flock* in the Escorial, near Madrid.[1]

MARTHA WOLFF

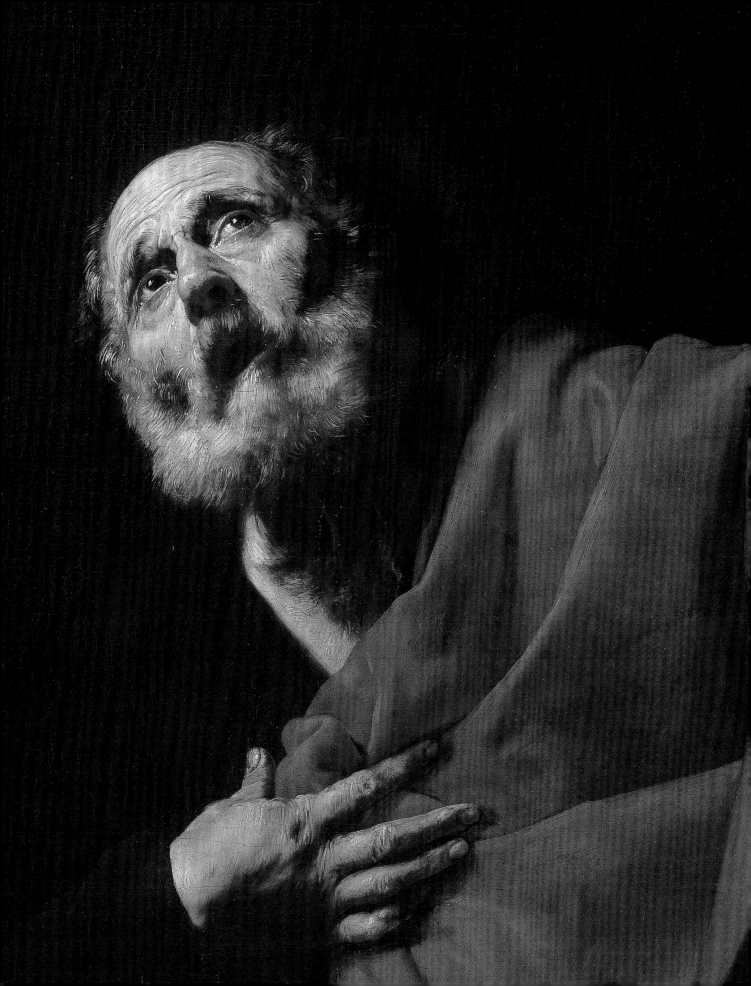

Two Cows and a Young Bull beside a Fence in a Meadow

1647

Paulus Potter

(Dutch; 1625–1654)

Oil on panel; 49.5 x 37.2 cm (19 1/2 x 14 3/4 in.)

Inscribed: *Paulus. Potter. f. / 1647* (on the fence)

IN LOVING MEMORY OF HAROLD T. MARTIN, FROM
ELOISE T. MARTIN, WIFE, AND JOYCE MARTIN BROWN,
DAUGHTER; CHARLES H. AND MARY F. S. WORCESTER
COLLECTION; LACY ARMOUR ENDOWMENT; THROUGH
PRIOR GIFT OF FRANK H. AND LOUISE B. WOODS,
1997.336

Fueled by a prosperous mercantile economy, seventeenth-century Holland was remarkable for the number of painters who produced excellent work within their own distinctive areas of specialization. Artists could find a market for such diverse painting types as still lifes of flowers, architectural subjects, scenes of peasant life, views of Italy, or native pastoral landscapes. Highly finished pictures were especially prized, since they displayed the painter's ability to imitate effects of texture and light. In a working life of less than ten years, Paulus Potter established a successful career as a painter of animals within the Dutch landscape, working for members of the Netherlands' landed and professional elite. Potter's painterly realism is deeply rooted in the Dutch countryside; this local quality, as well as the wit and humanity he brought to his animal subjects, have made him one of the most beloved masters in his native land, bringing him into the same company as Rembrandt van Rijn, Jan Steen, and Jan Vermeer.

Potter painted *Two Cows and a Young Bull beside a Fence in a Meadow* toward the beginning of his career, in the same year as his most famous work, the monumental *Young Bull* in the Mauritshuis, The Hague.[1] In this modestly scaled picture, made for a collector's cabinet, Potter focused not just on re-creating the textures of hide and meadow, but on suggesting the relationship between the three creatures, who take on almost human qualities. The young bull gazes boldly out of the picture, standing guard over the two docile milk cows. His alert form, silhouetted against a wonderfully changeable and luminous sky, seems to signal pride in his domain. Using a rich, buttery application of paint, Potter evoked the substance of the animals, the well-trodden pasture, and a spring landscape, giving a powerful presence to this small panel.

MARTHA WOLFF

Pergola with Oranges

c. 1834

Thomas Fearnley

(Norwegian; 1802–1842)

Oil on paper, mounted on canvas; 28 x 37 cm (11 x 14 1/2 in.)

Inscribed: *Fearnley* (at lower right)

Thomas Fearnley, a Norwegian artist of English descent, was a significant member of a group of Scandinavian artists, including Johan Christian Dahl and Johan Fredrik Eckersberg, who helped bring about the golden age of northern painting in the nineteenth century. Like many of his colleagues, Fearnley felt that the study of atmosphere could only be fully realized in the clear light of the Mediterranean. In 1832, at the age of thirty, he traveled south, reaching Rome at the end of the year.

Pergola with Oranges was probably painted in the summer of 1834, when Fearnley and several fellow artists worked in Sorrento, a coastal town south of Naples. For this exquisite oil, Fearnley used paper as a support, a common practice that enabled artists to work easily in the countryside; such studies could be mounted on a stronger support (such as canvas) later. Here Fearnley created a view of a pergola lined with orange trees. In the middle distance a man sits with a sketch pad in hand, recording the vision around him—perhaps a reference to Fearnley himself or to one of his artistic companions. He signed the work illusionistically on the lower right, making his signature part of the stone wall.

Although small in scale, this work is more than a mere *étude*, or study; its carefully constructed composition and highly finished surface give it a commanding presence. The entire picture is suffused with dappled light playing across various surfaces: bricks, leaves, stucco, and terracotta. Fearnley used small, careful brushstrokes and delicate impasto to build up a glowing surface of ochers, oranges, and yellows, richly evoking the colors and atmosphere of the pergola and the surrounding fruit trees. In its combination of observation of atmosphere with a beautifully balanced composition, it is one of the artist's finest works.

MARY WEAVER CHAPIN

The Marsh

1840

Constant Troyon
(French; 1810–1865)
Oil on canvas; 93 x 140 cm (36 5/8 x 55 1/8 in.)

Constant Troyon was a major figure in the development of nineteenth-century French landscape painting. Born into a family of porcelain painters, he began his career in the famous Sèvres manufactory, and for many years traveled extensively in search of landscape ideas to decorate Sèvres products. By the 1830s, however, he had turned to painting on canvas rather than porcelain, and associated with artists such as Eugène Delacroix, Jules Dupré, and Paul Huet, who came to be known as the "Generation of 1830" after the democratic July Revolution of that year. Some of this group, including Troyon, later joined with Jean François Millet and Thèodore Rousseau in the Barbizon School, named after the village in the Forest of Fontainebleau where they often lived and worked. Inspired by English landscape painting, they looked especially to the example of John Constable, who painted from direct observation and focused on seemingly insignificant natural effects. Constable presented an innovative alternative to the tired academic tradition of showing carefully finished, highly idealized images of sites famous for their beauty or historical associations.

In this panoramic canvas Troyon presents a rural spot, perhaps in Brittany, that is animated by washerwomen who have laid their clothing out to dry on nearby rocks and shrubs. The true subject of the picture, however, is light, which suffuses the changing, cloudy sky and plays on gently sloping grasslands and groves. Troyon's carefully constructed and balanced composition emphasizes the monumental grandeur of this otherwise unremarkable site. The textured, clearly visible brushwork preserves the freshness of the scene and gives the impression that the work itself sprang from the artist's direct observation of nature.

Traveling to Holland in 1847, Troyon was struck by the work of seventeenth-century Dutch animal painters such as Paulus Potter (see pp. 60–61) and increasingly turned his attention to representing subjects set within atmospheric landscapes. These paintings consolidated his reputation, and by the 1860s he had a greater impact on the international art scene than any of his French colleagues. In this earlier work, however, Troyon focused primarily on landscape, achieving a new kind of pictorial expression that anticipates Impressionism in its free, painterly handling and its feeling for light and nature. Indeed, it is significant that when the young Claude Monet first arrived in Paris in May 1859, he visited Troyon and sought the older painter's advice.

GLORIA GROOM

Calf's Head and Ox Tongue

c. 1882

Gustave Caillebotte
(French; 1848–1894)
Oil on canvas; 73 x 54 cm (28 3/8 x 21 1/4 in.)

MAJOR ACQUISITIONS CENTENNIAL ENDOWMENT,
1999.561

It is surprising and even shocking that the same artist who painted the elegant and monumental *Paris Street; Rainy Day* (1877; The Art Institute of Chicago) could have conceived, five years later, this image of raw beef hanging from hooks in a butcher's shop.[1] Gustave Caillebotte made his name with canvases that focused on modern life in the city and suburbs; around 1881, when he quit exhibiting with the Impressionists altogether, he began to paint still lifes. These works included traditional representations of lobsters, oysters, and other delicacies elegantly dressed on the sideboards and tables of bourgeois homes.[2] The artist also, however, undertook a series of extraordinarily direct and confrontational paintings in which he depicted fresh meat on display, reinventing the genre in radical and unprecedented ways. Of these, *Calf's Head and Ox Tongue* is arguably the most compelling. In this image, Caillebotte seems to have indulged not only in the process of painting, but also in a wry commentary on the ways in which his contemporaries approached the still life.

Claude Monet, for example, would never have undertaken a subject as brutal and unforgiving as an ox tongue. For Monet and his fellow Impressionist Pierre Auguste Renoir, the still life was appealing because of its accessibility: its mission was to please and to sell. Not so with the wealthy Caillebotte, who, not needing to profit from his artwork, could afford to turn the tables on a genre with a long art-historical pedigree. On the one hand, he drew on the still-life tradition of seventeenth-century Dutch painters such as Rembrandt van Rijn, which was revivified by nineteenth-century artists including François Bonvin, who painted convincingly bloody slabs of beef hanging in modest interiors. On the other, he subverted it: rather than using the dark colors favored by Dutch masters and contemporary realists such as Bonvin, Caillebotte adopted a lively, insouciant palette, setting the fiery, red-and-orange tongue and soft, bluish-mauve head against a pale, blue-gray background. Although the hooks at top clearly underscore the fact that this is lifeless flesh set out for purchase, Caillebotte's highly decorative choice of colors and juxtaposition of objects goes beyond "dead nature," inviting comparison with twentieth-century artists such as Chaim Soutine and Lucian Freud.

GLORIA GROOM

Lovers Surprised by Death

1510

Hans Burgkmair the Elder
(German; 1473–1531)
Chiaroscuro woodcut printed in three shades of brown on ivory
laid paper; state 1b of 3; 21.7 x 15.7 cm (8 9/16 x 6 3/16 in.)

AMANDA JOHNSON AND MARION LIVINGSTON
ENDOWMENT, 1997.306

Hans Burgkmair's *Lovers Surprised by Death* is inarguably one of the most compelling images in any medium produced in northern Europe during the Renaissance. Among prints of the period, the enduring fascination of this image and its enormous subsequent influence are rivaled only, perhaps, by Albrecht Dürer's *Melencolia I* (1514).

Traditionally, this work's renown rested primarily on Burgkmair's technical virtuosity and on his brilliant melding of the grim northern imagery of death with a classicized, beautifully proportioned architectural setting. Recently, however, scholars have recognized the work's pivotal importance to the history of color printmaking.[1] In fact, the image represents a major cognitive leap on the part of the artist, who was the first to visualize and then to compose an organic, three-dimensional composition by juxtaposing and overlapping three tones, which he printed from three different wood blocks.[2] Prior to this innovation, color woodcuts were created by printing a linear design (line block) over a single tone (tone block). Even this relatively simple concept was revolutionary; the majority of color prints in this period were still being colored by hand.

Burgkmair was the foremost designer of woodcuts in Renaissance Augsburg, seat of the Imperial Council and the center from which the Holy Roman Emperor, Maximilian I, organized his ambitious artistic commissions, pioneering the use of printed imagery for political propaganda. The emperor's patronage gave the artist's career tremendous impetus over a thirteen-year period, during which Burgkmair produced such major works as *Triumphal Procession of Maximilian* (1517–18) and *Equestrian Portrait of Emperor Maximilian I*, the latter represented at the Art Institute by a splendid presentation impression printed in gold on vellum (fig. 1).

In *Lovers Surprised by Death*, the emaciated, winged figure of Death prepares to rip out the living soul of a conquered young soldier while catching in his teeth the skirt of a fleeing maiden. Themes derived from the Dance of Death, an allegory in which Death overcomes people of all ages and levels of society, pervaded German art in the late medieval and Renaissance periods. Burgkmair updated the subject by including classical elements such as the clothing and the architectural style, borrowed from Italy. The gondola and distinctive chimney-pots in the background identify the setting as Venice, which Burgkmair had visited several years earlier.[4] The pose of the terrified woman, who lunges away from Death with her arms outstretched, offers a reprise on the classical theme of the virgin huntress Daphne, who fled Apollo's amorous grasp. *Lovers Surprised by Death* is a Renaissance work of great potency but also of enormous historical significance, displaying a progressive approach to both technique and iconography.

MARTHA TEDESCHI

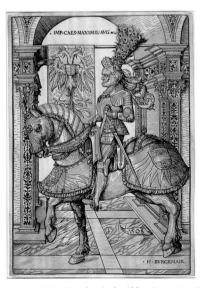

FIGURE 1 Hans Burgkmair the Elder. *Equestrian Portrait of Emperor Maximilian I*, 1508. Woodcut printed from two line blocks in black and gold on vellum; image 31.8 x 22.5 cm (12 1/2 x 8 7/8 in.), sheet 32.3 x 23.5 cm (12 3/4 x 9 1/4 in.). The Art Institute of Chicago, Kate S. Buckingham Fund (1961.3).

An Allegory: The Phoenix, or The Statue Overthrown

1658

Rembrandt Harmenszoon van Rijn
(Dutch; 1606–1669)
Etching and drypoint on ivory laid paper; only state;
17.9 x 18.3 cm (7 x 7 ¼ in.)
Inscribed on plate: *Rembrandt f. 1658*

CLARENCE BUCKINGHAM AND AMANDA S. JOHNSON AND
MARION LIVINGSTON ENDOWMENTS, 2001.122

Late in his printmaking career, Rembrandt produced a large, visionary etching of an enigmatic subject—the phoenix, the mythological bird that consumes itself in fire only to be miraculously reborn. Rembrandt's vision is one of startling force and immediacy: a triumphant, awkwardly endearing phoenix springs to life, heralded by trumpeting putti, and unseating a sculpture of a male figure from its base. Clearly a product of Rembrandt's vivid imagination, this perplexing scene is notable for both its immediacy and its implausibility. Using the spare, blunt-etched lines of his late style, the artist characterized the phoenix as a slightly preposterous fledgling and the statue as a perhaps less-than-ideal form. The animated crowd, which includes a swaddled infant, gazes upward, touched by the rays of a celestial vision occurring in broad daylight.

The image has inspired a number of interpretations. One is that it represents Rembrandt's victory over his creditors and critics and exists as a defiant reminder of his creative prowess.[1] Recently bankrupt, he had been evicted from his luxurious home, stripped of his significant art collection, and deprived of a lifetime's output of etched copper plates (and all the potential revenue they promised). He was, moreover, spurned by his friends and his church for his unmarried relationship with Hendrickje Stoffels, formerly his housekeeper and his son's nurse.

Scholars have also attributed various political and religious meanings to the work. Some have suggested that it represents the French defeat of the Spaniards in the Battle of the Dunes (1658) and the election of the Holy Roman Emperor Leopold I in the same year.[2] Others have explained the print as a piece of political allegory, and the phoenix as a symbol for the young prince William III of Orange, who was born just eight days after his father died.[3] But the creature also appeared as the arms of the Portuguese Jewish community in seventeenth-century Amsterdam, and might well relate to Rembrandt's relationships with its members, some of whose portraits he painted.

Whatever its allegorical significance, the image constitutes Rembrandt's apotheosis as a printmaker at the end of a long and fruitful career. In this bold, imaginative work, the artist achieved a late statement of vitality and daring, of directness and power, that proves his talent's triumphant survival.

SUZANNE FOLDS McCULLAGH

Jean Joseph Cassanea de Mondonville

1746/47

Maurice Quentin de La Tour

(French; 1704–1788)

Pastel on paper laid down on board; 61.2 x 49.4 cm (24 1/8 x 19 1/2 in.)

Pastel on paper laid down on canvas, enlarged by the artist with a band of paper about 3 cm high; 66 x 55 cm (26 x 21 5/8 in.)

CHARLES H. AND MARY F. S. WORCESTER COLLECTION, 2001.52–53

Maurice Quentin de La Tour is widely considered to be the greatest pastel portraitist of eighteenth-century France. He was interested above all in the psychology of his models, and tried to grasp the essence of each personality with spirit and a great mastery of technique. A native of Saint-Quentin in northern France, the young La Tour established himself in the capital in 1727; ten years later he was allowed to show his pastels in the annual Salons organized by the Royal Academy of Painting and Sculpture, which accepted him as a member in 1746. His reputation as a virtuoso portraitist soon gained him the favor of the princely and aristocratic world, and in 1750 he was named Painter to the King.

Anne Jeanne Cassanea de Mondonville

1747/53

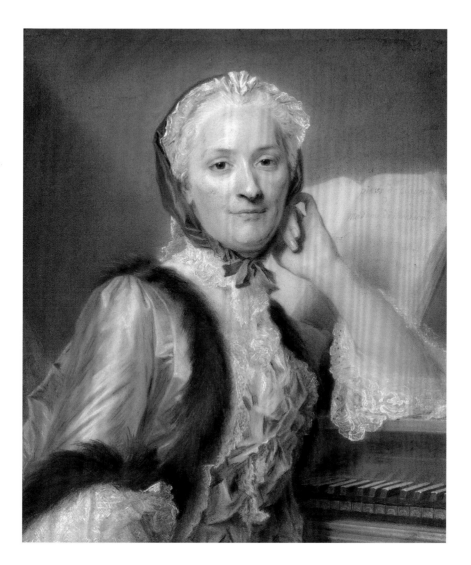

These two portraits are among La Tour's most renowned pastels. Jean Joseph Cassanea de Mondonville (1711–1772), a celebrated violinist and composer, was second in command at the royal chapel and director of the Orchestra of the Spiritual Concert, both important musical institutions in eighteenth-century Paris. La Tour frequented Mondonville's salons, and was a close friend when he captured this informal but sympathetic pose of the musician tuning his violin. The pastel was shown in the Salon of 1747, the same year that the sitter married Anne Jeanne Boucon (1708–1780).

Some time later Madame de Mondonville, a talented musician and artist in her own right, asked La Tour to make her likeness as well. One contemporary critic, Pierre Estève, noted that the pastel was "astonishing for its resemblance."[1] In the portrait, which was exhibited in the Salon of 1753, La Tour shows his subject leaning on a harpsichord that holds a score of her own composition. According to the eighteenth-century collector Pierre Jean Mariette, the artist created this work in one sitting and later had a falling out with the Mondonville couple, who thought that he would allow them to pay him half his usual rate.[2] Although La Tour did not conceive these two works as a pair, they illustrate vividly both the affection and familiarity he held for Mondonville and the temperamental challenge presented by his more difficult wife.

SUZANNE FOLDS McCULLAGH

Corte del Paradiso

1880

James McNeill Whistler
(American; 1834–1903)
Pastel and chalk on brown-gray wove paper;
29.9 x 14.7 cm (11 3/4 x 5 3/4 in.)
Signed in chalk with the artist's butterfly monogram

WALTER AITKEN, MARGARET DAY BLAKE, HAROLD JOACHIM MEMORIAL, JULIUS LEWIS, AND SARA R. SHOREY ENDOWMENTS; SANDRA L. GRUNG, MR. AND MRS. DAVID C. HILLIARD, AND JULIUS LEWIS FUNDS; RESTRICTED GIFTS OF WILLIAM VANCE AND PAMELA KELLEY ARMOUR; THROUGH PRIOR ACQUISITIONS OF KATHARINE KUH, 2002.679

The American expatriate James McNeill Whistler was a highly original pastelist, who, like his contemporaries Mary Cassatt and Edgar Degas, was drawn to the medium's vibrant hues and subtle effects. Unlike these artists, however, Whistler did not build up the surface of his pastel or blend it to resemble oil painting. Instead, he used individual touches of brilliant pastel to highlight his black chalk drawings. His approach was decidedly avant-garde: he left much of the dark brown paper bare, picking out motifs in the scene with small touches of pure pigment that lead the eye to explore the picture's surface. One such image, *Corte del Paradiso* is a small gem that functions simultaneously as an abstract arrangement of color and as a picturesque vignette of Venetian street life. It is perfectly preserved in a deep, reeded gold frame of Whistler's own design, the proportions intentionally made narrower than usual to emphasize the radical verticality of the composition.[1]

Whistler came into his own as a pastelist while living in Venice during 1879 and 1880, following the bankruptcy and public humiliation brought on by his famous libel suit against John Ruskin; the art critic had accused Whistler of "flinging a pot of paint" in the public's face when he exhibited his distilled, nearly abstract "Nocturnes."[2] In many ways Whistler was reinventing himself in this period.[3] Needing desperately to find a way to make money from his art, and at the same time striving to push his own progressive aesthetic ideas a step further, he developed a new style of etching. Rather than relying entirely on etched lines to produce an identical image with each printing, Whistler used line sparingly in his Venice etchings. He also inked each impression differently, creating unique, painterly images. In the same period, he sought out the hidden alleyways and courtyards of Venice for his pastel drawings. In these, too, he adopted an abbreviated handling of the medium, capturing the architectural framework of his subject with a few, rapidly drawn lines in black chalk. He would then highlight picturesque details in a vibrant red or vivid turquoise, creating a dynamic—and very modern—interplay of line, color, and form.

The site that Whistler evoked so sensitively in this work still exists. Margaret F. MacDonald's description of the place (see fig. 1) suggests why Whistler might have selected it as his subject: "The tiny sheltered courtyard has remained unchanged to this day. It is not far from the Riva degli Schiavone, and yet quite off the tourist track. It was a working-class area, busy with small shops and markets, but the Corte del Paradiso was an oasis of calm where Whistler could work undisturbed."[4]

MARTHA TEDESCHI

FIGURE 1 Corte del Paradiso, Venice.
Photo: A. I. Grieve.

The Carrot Puller

1885

Vincent van Gogh
(Dutch; 1853–1890)
Black chalk with stumping and erasing on cream wove paper;
252 x 41.5 cm (20 ¹/₂ x 16³/8 in.)

GIFT OF DOROTHY BRAUDE EDINBURG TO THE HARRY B.
AND BESSIE K. BRAUDE MEMORIAL COLLECTION, 1998.697

This impressive sheet, which features a peasant woman bending at her labors, is one of a group of similarly scaled black chalk drawings of individual figures that Vincent van Gogh produced in the summer of 1885.[1] The impetus for these works was the criticism the artist received for *The Potato Eaters* (Amsterdam, Van Gogh Museum), the ambitious coming-of-age canvas he had completed in the spring, from the two critics whose approval was crucial: his art-dealer brother, Theo, and a friend, the Dutch artist Anton van Rappard.[2] Both men found the torsos of the figures in the picture inadequately realized, but Van Rappard was especially harsh, calling into question the artist's claim to the lineage of Jean François Millet, the famous French "peasant painter" whom he especially revered.

While Van Gogh railed against the validity of a judgment based on what he considered to be hollow academic criteria, he nonetheless took action. Earlier, in preparation for *The Potato Eaters*, he had drawn and painted numerous studies of the heads of peasants living around Neunen, the town in North Brabant where he was staying with his parents.[3] Now, addressing his perceived shortcomings, he applied himself anew to certain fine points of figure drawing, observing his humble neighbors tilling the soil.

What is remarkable about this drawing—and what distances it from Millet's depictions of working women bending—is that Van Gogh insisted on viewing his subject from behind, and exaggerated her hips and buttocks. Indeed, this visual emphasis has been seen as courting association "with a sexual position for a form of intercourse known as *more ferrarum*, in the fashion of animals."[4] Moreover, as scholars have observed, the very act of bending held specific class connotations: neither the posture nor its representation was appropriate to a lady, and Van Gogh had his peasant model take up a pose that bourgeois women such as his mother and sisters would never have adopted in front of a man and a stranger.[5]

To be sure, the artist's own professed identification with Neunen's peasantry was inevitably complicated by his privileged social position as the son of the local minister. Indeed, it is the way in which he represents his subject—combining respect for the virtues of work with an almost comically inappropriate viewpoint—that endows this boldly executed drawing with its remarkable power.

DOUGLAS DRUICK

arracheuse de carottes (hiver)

Design for a Fan Featuring a Landscape and a Statue of the Goddess Hina

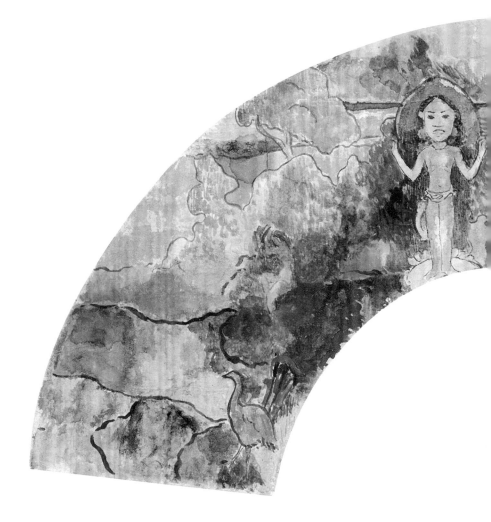

1902/03

Paul Gauguin

(French; 1848–1903)

Gouache and watercolor, with touches of pastel, over graphite, on pieced off-white laid Japanese paper, laid down on off-white wove paper; 20.8 x 41.7 cm (8 3/16 x 16 3/8 in.)

GIFT OF EDWARD MCCORMICK BLAIR, 2002.225

During the 1880s and 1890s, fan-shaped compositions enjoyed a vogue that was fed by the Parisan vanguard's interest in Japanese art, which had become increasingly visible and available. In planning the third Impressionist exhibition (1879), for example, Edgar Degas envisaged a gallery devoted entirely to his own fans and those of his fellow participants, including Camille Pissarro.¹ Paul Gauguin, who first exhibited with the Impressionists that year at the invitation of Degas and Pissarro, was a great admirer of both men. But it was not until around 1884 that he first attempted to use this eccentric, inherently decorative format, responding to its challenges with a creative process that involved borrowing and recombining motifs from his own paintings, and, on two occasions, from the work of Pissarro and Paul Cézanne as well.² Gauguin worked on fan designs sporad-

ically throughout the remainder of his career, realizing over two dozen in a variety of media—gouache, lithography, and watercolor—on supports that include canvas, paper, and silk. None of these were mounted for actual use.

The Blair gouache-and-watercolor may well be the last such object Gauguin made. In this late work, which he produced after his arrival in the Marquesas Islands in the fall of 1901, the artist depicted an idyllic coastal landscape. Traversed horizontally by a river, it features motifs taken from paintings he had made after returning from France to Tahiti in 1895. As in his magnum opus, *Where Do We Come From? What Are We? Where Are We Going?* (1897; Boston, Museum of Fine Arts), a blue-hued figure of Hina, the Polynesian goddess of the moon and regeneration, dominates the scene. Just to the left of the goddess, and also drawn from the same canvas, is a nude

female bathing at water's edge; on the near side of the river, an exotic bird recalls those found in that masterpiece and other paintings of the same period. Gauguin also borrowed one prominent image from a more recent work, deriving the equestrian group at the extreme right from *Riders on the Beach* (1902; private collection), painted on the island of Hivaoa in the Marquesas.[3] In this fan we discover a world in which the logic of space and temporal sequence collapses. Essentially retrospective in nature, this is a landscape of memory and dream, an imaginative consolation, perhaps, for the lost Eden Gauguin had failed to find in fact and sought to recreate in his art.

DOUGLAS DRUICK

The Weeping Woman I

July 1, 1937

Pablo Picasso
(Spanish; 1881–1963)

Etching, aquatint, drypoint, and scraper on cream wove paper; state 7 of 7; image 69.5 x 49.7 cm (27 3/8 x 19 5/8 in.), sheet 77.4 x 56.8 cm (30 1/2 x 22 3/8 in.)

THROUGH PRIOR ACQUISITION OF THE MARTIN A. RYERSON COLLECTION WITH THE ASSISTANCE OF THE NOEL AND FLORENCE ROTHMAN FAMILY AND THE MARGARET FISHER ENDOWMENT, 1994.707

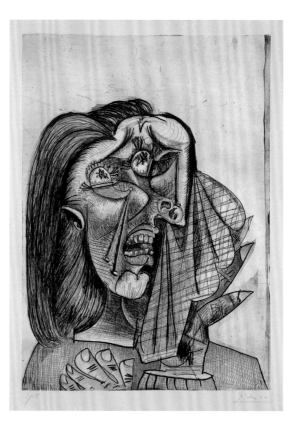

A ferocious image of grief, at once compelling and frightening, *The Weeping Woman I* is one of the most powerful works that Pablo Picasso undertook in the wake of his seminal *Guernica* (Madrid, Museo del Prado).[1] On April 26, 1937, the forces of General Francisco Franco bombed the undefended town of Guernica in the Basque region of northern Spain. Four days later Picasso began work on *Guernica*, a commission for the Spanish Pavilion at the 1937 Exhibition universelle in Paris. An expression of the horrors of war, the painting refers directly to the carnage endured by helpless civilians and reflects the artist's own critique of fascist tyranny.

After completing *Guernica*, Picasso continued to be drawn to the subject of agonized grief. Between June and December 1937, he undertook a series of drawings, paintings, and prints known as "The Weeping Women," in which he focused and elaborated on two figures first presented in *Guernica*.[2] These tormented women, as if the catastrophe's official mourners, became potent icons of despair for Picasso. It is also possible that the figure appearing in this print emerged from the artist's sensitivity to romantic conflicts as well as military ones—with her distinctive black hair and long, tapered fingernails, she resembles his lover, the Surrealist photographer Dora Maar.[3]

In *The Weeping Woman I*, the most monumental and arguably the most potent graphic expression of his career, Picasso drew inspiration not only from contemporary events but also from sixteenth- and seventeenth-century religious imagery. In his mourning figure, the artist mod-ernized the traditional theme of the Virgin Mary lamenting the death of her son, Jesus. Like Titian's *Mater Dolorosa* (1554; Madrid, Museo del Prado), which Picasso studied as a young artist, this work focuses on the figure's face and hands, concentrating on the visceral manifestations of her agony.[4] Distorted in a silent shriek of pain, she raises a scissorlike hand to wipe away the spiked tears that incise the overlapping planes of her contorted face.

The importance Picasso accorded this etching is suggested not only in its size—it was the largest plate he had yet attempted—but also in the energy he bestowed upon it. Laboring intensively, he developed the finished print through seven independent stages, or states. It seems that the artist felt the need to work and rework this image, perhaps in an effort to exorcise the demons the war and his difficult relationship with Dora Maar had summoned upon him.

JAY A. CLARKE

Black and White

1953

Lee Krasner

(American; 1908–1984)

Brush and black paint, and cut and torn painted paper collage with adhesive residue on cream laid paper; 76.6 x 57.1 cm (30 1/8 x 22 1/2 in.)

MARGARET FISHER ENDOWMENT, 1994.245

Since her death, Lee Krasner has finally received the credit she deserves as a first-rate, first-generation Abstract Expressionist painter. Krasner's pictures from the 1940s are informed by her understanding of the Abstract Expressionist idea: to infuse abstract, painterly forms with mysterious and significant content. The substantial body of work she created from that period onward shows her sustained development toward a refined expression of this concept.

The first major evidence that Krasner had begun to realize her own, individual statement of Abstract Expressionist aims is the "Little Image" series, which she began in late 1946 or early 1947 and continued until 1950.[1] The densely painted, light-filled surfaces of these small pictures vibrate with abstract shapes, simultaneously readable as constellations, eyes, calligraphic hieroglyphs, microscopic organisms, or spirals. The artist arranged these multireferential signs in an allover manner upon a grid structure that was strongly inspired by her training as a Cubist.

Krasner worked in cycles throughout her career, never spending more than four or five years on a series. In 1951 her pictures became broader and thinner, with an organic atmosphere and vertical strips that incorporate calligraphic shapes. These experiments were her attempt to phase out the atomized, compartmentalized "Little Image" paintings while searching for a genuinely post-Cubist style. Between 1953 and 1955 she became discontented with these most recent canvases and used all but two of them to make her first series of collaged paintings. The latter were, in fact, modeled on a group of earlier paper collages, one of the first and most important being *Black and White*.[2] The drawings that Krasner disassembled to create these early collages closely echoed her husband Jackson Pollock's work from the same period. According to art historian Ellen Landau, however, it is difficult to stipulate which of the couple originated the strategy of cannibalizing previous works to create new ones. Throughout her career, Krasner employed it more consistently than did Pollock.[3]

In *Black and White* Krasner not only appropriated her own discarded markings but also referred to Pollock's own, early-1940s tactic of quoting Picasso's studio subjects.[4] In this work Krasner reversed the gender implications of Picasso's prototypes by showing, at right, a female figure who may be a painter contemplating her works of art, or perhaps a woman looking in a mirror.[5] The artist's redeployment of studio scraps in a new context helped her, paradoxically, to mark out new aesthetic territory.

MARK PASCALE

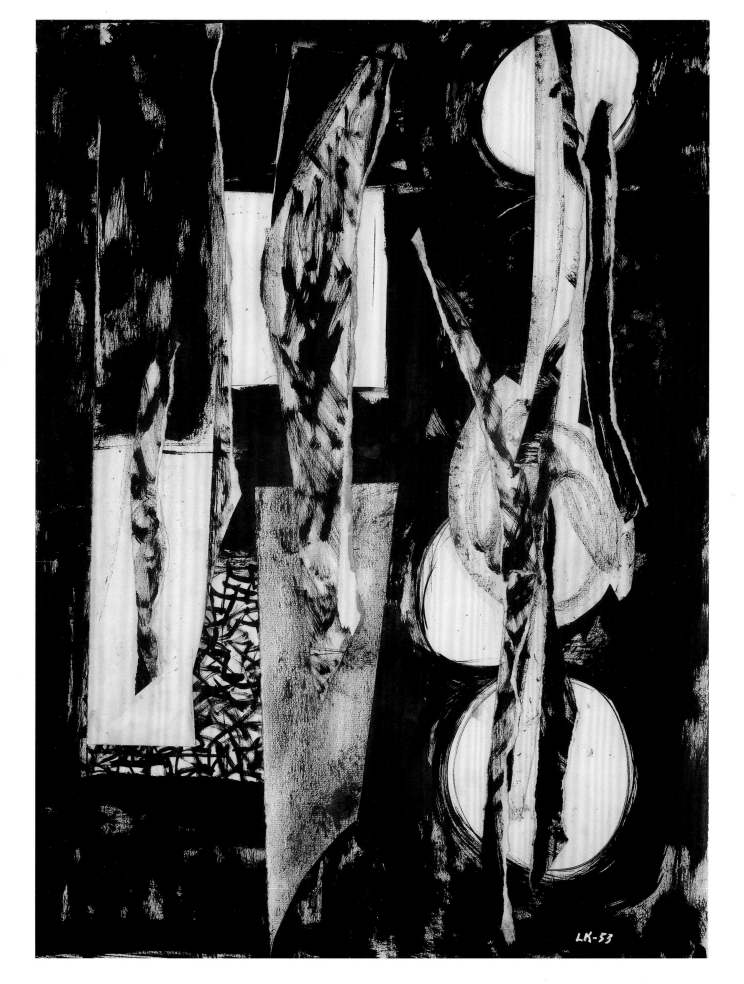

LK-53

Alka Seltzer

1966

Roy Lichtenstein

(American; 1923–1997)

Graphite with scraping and lithographic crayon pochoir on cream wove paper; image 75.1 x 55.7 cm (29 5/8 x 21 7/8 in.), sheet 76.3 x 56.7 cm (30 x 22 3/8 in.)

MARGARET FISHER ENDOWMENT, 1993.176

Roy Lichtenstein had been exhibiting in galleries for nearly ten years when, in 1961, he dramatically changed the course of his work. Prompted by the comic strips on his childrens' gum wrappers, he began to create paintings based upon cartoon images. The reductive style that soon emerged became his particular contribution to the idiom known as Pop Art.[1] Drawing was at the core of the formal strategy that made this innovation possible and remained essential to the creation of all Lichtenstein's art.

From around 1961 until 1968, the artist created a group of highly finished drawings in black and white in which he first demonstrated his subversive use of commercial illustration techniques, depicting common objects such as a ball of twine, a wristwatch, or a zipper in a monumental way.[2] Within this series very few sheets possess the scale of *Alka Seltzer*, which exists as an independent work and was never used as the basis for a similar painting. Indeed, this drawing is unique among Lichtenstein's finished works on paper and stands as an important icon within his entire oeuvre.

More than any other core American Pop artist, Lichtenstein considered himself a formalist whose primary interest was to construct unified images derived from both art-historical and commercial sources. As the artist Larry Rivers commented, "Roy got the hand out of art, and put the brain in."[3] With an agreeable sarcasm, Lichtenstein exploited everyday practices of visual representation and magnified them. In *Alka Seltzer*, for example, he indicated the gas bubbles rising over the glass by meticulously scraping away extra spaces from a field of imitation, hand-stenciled Benday dots.[4] To signify the reflective surface of the glass, he drew flat, black graphite shapes—a parody, like the dots, of the reductive, linecut effect of pulp advertising. Here we can see how the artist's use of mechanical reproduction conventions served to unify his composition and produce movement and volume on a two-dimensional surface.[5]

Alka Seltzer is one of Lichtenstein's watershed works because it shows the artist summing up his early graphic techniques and introducing what would become his most significant formal preoccupations in the years that followed. These include both the Art Deco motifs that he went on to explore in his "Mirror" series and WPA-style murals of the late 1960s through early 1970s, and the *Brushstroke* paintings of the later 1960s, which are suggested here by the trail and bubbles of the descending tablet.[6]

MARK PASCALE

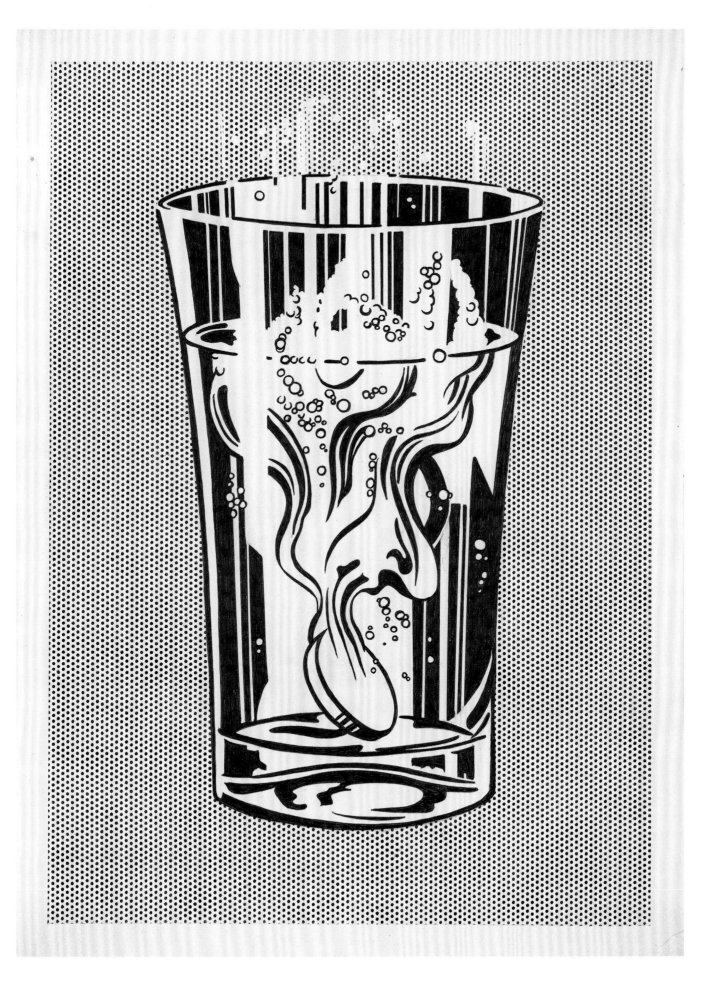

Partly on This Side, Partly on the Other Side (Teils Diesseits teils Jenseits)

1979

Sigmar Polke

(German, born 1941)

Sprayed acrylic on paper with linear cutouts;
99.8 x 69.8 cm (39 1/4 x 27 1/2 in.)

GIFT OF SUSAN AND LEWIS MANILOW, 2001.714

At age twelve, Sigmar Polke left communist East Germany with his family and settled in Dusseldorf, then part of West Germany. He enrolled in the city's Staatliche Kunstakademie in 1961, the same year the Berlin Wall was erected. In East Germany the reigning artistic style was representational, government-endorsed Socialist Realism; West Germany, still trying to expel the realist aesthetic of Nazi-sanctioned art from its national consciousness, promoted abstraction. Polke daringly rejected abstraction, however, and courted censure by embracing Pop Art, with its images gleaned from advertising and mass culture. Polke did not simply imitate his American contemporaries, but used Pop aesthetics as a means of questioning the social character of an increasingly capitalist West Germany.[1]

In his work Polke frequently experiments with overlapping and layering different forms. This interest is apparent in *Partly on This Side, Partly on the Other Side*, which he created by covering a sheet of paper with stencils and then spraying them with blue, brown, olive-green, red, and yellow acrylic paints. Each figural element in the composition—the central couple, the isolated, red man who stands between them, and the two birdlike forms whose heads are visible at the upper left and lower right—overlap, creating a profusion of incongruous symbols. The artist also superimposed a cut-paper image of an elfin female figure lassoing a tuxedoed centaur, adding yet another physical and interpretive layer. Polke presented viewers with the challenge of sorting through the work's possible meanings: Does it merely signify his interest in manipulating images from 1950s and 1960s magazines and advertisements? Is it a formal play on issues of artistic uniqueness and reproducibility?[2] Or is it perhaps a commentary on the haphazard interactions of the men and women depicted?

One source of the work's intentionally slippery, even ironic quality is the multivalent title, which seems to describe, on the one hand, the shifting, transparent planes of the drawing itself. It may also suggest Polke's experience of living in a divided Germany, with part of the country on one side of the Iron Curtain and part on the other. Since the German word *Jenseits* can be translated as "the beyond" or "the hereafter," the work could additionally refer to humanity's existence both in this life and the world to come. In the end, however, what this piece demonstrates most powerfully is Polke's talent at combining technical daring, a complex iconographic vocabulary, and linguistic wordplay to create images that both inspire and elude interpretation.

JAY A. CLARKE

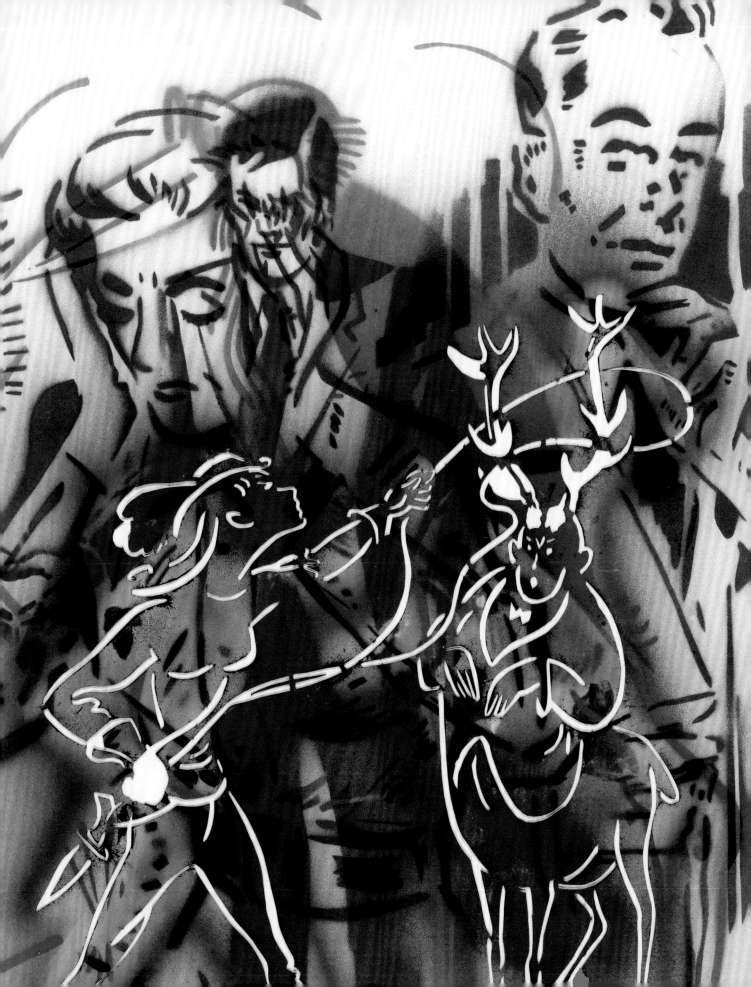

Notes

Card Table, pp. 6–7.
1. Quoted in Charles F. Montgomery, *American Furniture: The Federal Period* (New York, 1966), p. 365.
2. Quoted in Peter M. Kenny, Frances F. Bretter, and Ulrich Leben, *Honoré Lannuier, Cabinetmaker from Paris: The Life and Work of a French Ébéniste in Federal New York*, exh. cat. (New York, 1998), pp. 31, 33–34.
3. These tables include those found in the collections of the High Museum of Art, Atlanta; the Huntington Library, San Marino, Calif.; the Maryland Historical Society, Baltimore; and the Metropolitan Museum of Art, New York. For a detailed study of these works, see ibid., pp. 209–212.

Zenobia, Queen of Palmyra, pp. 8–9.
1. Quoted in Kathryn Greenthal et al., *American Figurative Sculpture in the Museum of Fine Arts, Boston* (Boston, 1986), p. 162.
2. For the "white, marmorean flock," see Henry James, *William Wetmore Story and His Friends* (London, 1903), vol. 1, p. 257. See also William H. Gerdts, Jr., et al., *The White, Marmorean Flock: Nineteenth-Century American Women Neoclassical Sculptors*, exh. cat. (Poughkeepsie, N.Y., 1972).
3. Publications on the queen include William Ware, *Zenobia, Queen of the East, or, Letters from Palmyra* (London, 1838); and Anna Jameson's *Memoirs of Celebrated Female Sovereigns* (London, 1831). Hosmer's meticulous research for the sculpture included extensive consultations with Jameson.
4. Quoted in Joy S. Kasson, *Marble Queens and Captives: Women in Nineteenth-Century American Sculpture* (New Haven, 1990), p. 155.
5. The seven-foot version can be seen in a contemporary photograph of Alexander T. Stewart's home, illustrated in *Artistic Houses* 1 (1883); repr. in Gerdts et al. (note 2), fig. 4.
6. The accusation first appeared in an obituary of Alfred Gatley, a British sculptor. See "Mr. Alfred Gatley," *Art Journal* n.s. 2 (1863), p. 181.
7. See Harriet Hosmer, "The Process of Sculpture," *Atlantic Monthly* 14, 86 (Dec. 1864), pp. 734–37.

Machinist and Machinist's Apprentice, pp. 10–11.
1. See William H. Gerdts, Jr., et al., *The White, Marmorean Flock: Nineteenth-Century American Women Neoclassical Sculptors*, exh. cat. (Poughkeepsie, N.Y., 1972). For biographical information on Stebbins, see Charlotte Streifer Rubenstein, *American Women Sculptors: A History of Women Working in Three Dimensions* (Boston, 1990), pp. 63–66.
2. For a discussion of the Heckscher commission and the Goupil exhibition, see Elizabeth Milroy, "The Public Career of Emma Stebbins: Work in Marble," *Archives of American Art Journal* 33, 3 (1993), pp. 5–7. The pair remains in the Heckscher Museum of Art, Huntington, N.Y.
3. See John F. Kasson, *Civilizing the Machine: Technology and Republican Values in America, 1776–1900* (New York, 1976), esp. p. 129.

Fruit Piece, pp. 12–13.
1. See Martha Gandy Fales, "Hannah B. Skeele, Maine Artist," *Antiques* 121, 4 (Apr. 1982), pp. 915–21, for a discussion of Skeele's career.
2. See Kenneth L. Ames, *Death in the Dining Room and Other Tales of Victorian Culture* (Philadelphia, 1992), p. 78.

Double-Plated Lamp, pp. 14–15.
1. See Jane C. Nylander, *Our Own Snug Fireside: Images of the New England Home, 1760–1860* (New Haven, 1993), p. 107.
2. See *Catalogue of Petroleum or Kerosene Oil Lamps and Chandeliers Manufactured by the Boston and Sandwich Glass Co.* (Boston, n.d.), pl. 77.

York Harbor, Coast of Maine, pp. 16–17.
1. For more on Heade, see Theodore Stebbins, *The Life and Work of Martin Johnson Heade: A Critical Analysis and Catalogue Raisonné* (New Haven, 2000). In the course of his work, Stebbins identified the location of this painting (formerly known as *Sailing Sloops in a Bay*) as York Harbor, in southern Maine.
2. Barbara Novak has been the strongest proponent of the association of Luminism and Transcendentalism; see Barbara Novak, *Nature and Culture: American Landscape and Painting, 1825–1865* (New York, 1980). For a concise definition of Luminism, see idem, "On Defining Luminism," in *American Light: The Luminist Movement, 1850–1875*, exh. cat. (Washington, D.C., 1980), pp. 23–29.
3. Ralph Waldo Emerson, *The Selected Writings of Ralph Waldo Emerson*, ed. Brooks Atkinson (New York, 1950), p. 6.

Vase, pp. 18–19.
1. See James Mitchell, "Ott & Brewer: Etruria in America," *Winterthur Portfolio* 7 (1972), p. 223.
2. For more on the development of Belleek in America, see Alice Cooney Frelinghuysen, *American Porcelain, 1770–1920*, exh. cat. (New York, 1989), p. 45.

The Civil War Regalia of Major Levi Gheen McCauley, pp. 20–21.
1. For a study of Cope's artistic career, see Gertrude Grace Sill, *George Cope, 1855–1929*, exh. cat. (Chadds Ford, Penn., 1978).
2. Cécile Whiting, "Trompe l'oeil Painting and the Counterfeit Civil War," *Art Bulletin* 79 (June 1997), p. 256.
3. See *Art Institute of Chicago Museum Studies* 27, 1 (2001) for more on this issue.

Hall Chair, pp. 22–23.
1. For more on Rohlfs, see Michael L. James, *Drama in Design: The Life and Craft of Charles Rohlfs* (Buffalo, 1994).
2. Charlotte Moffit, "The Rohlfs Furniture," *House Beautiful* 7, 2 (Jan. 1900), p. 85.
3. Quoted in James (note 1), p. 236.
4. Rohlfs, quoted in Lola J. Diffin, "Artistic Designing of House Furniture," *Buffalo Courier*, Apr. 22, 1900; quoted in James (note 1), p. 236.
5. For this photograph, c. 1905, see James (note 1), p. 70.

Study for Ornamental Band No. 6, pp. 24–25.
1. For an image of Sullivan's work on the store, see John Zukowsky, ed., *Chicago Architecture, 1872–1922*, exh. cat. (Munich/Chicago, 1987), p. 142, fig. 10.
2. Wright's collection of Sullivan sketches is now in the Avery Architectural Library, Columbia University, and was published in Paul E. Sprague, *The Drawings of Louis Henry Sullivan: A Catalogue of the Frank Lloyd Wright Collection at the Avery Architectural Library* (Princeton, 1979).
3. For a photograph of the Auditorium Building, see Zukowsky (note 1), p. 58, fig. 2.

Section of a Lobby Lantern, pp. 26–27.
1. These include the Aisaku Hayashi House (Tokyo, 1917); Arinobo Fukuhara House (Hakone, 1918); Tazaemon Yamamura House (Ashiya, 1918); and Jiyu-Gakuen Girls' School (Toyko, 1921).
2. This initiative was cosponsored by the architect Kisho Kurokawa and the Japan Foundation.

Interior Perspective View of the United Airlines Terminal, pp. 30–31.
1. For more on Jahn's projects, see Helmut Jahn and Werner Sobek, *Archi-Neering: Helmut Jahn, Werner Sobek*, exh. cat. (Ostfildern, Germany, 1999).

Tomb Figure of a Winged Beast, pp. 32–33.
1. See, for example, inlaid bronze felines from the tomb of King Cuo (r. 327–313 B.C.) of the Zhongshan state in Pingshan, Hebei; small jade figures discovered near the tomb of Emperor Yuan (r. 48–33 B.C.) of the Western Han dynasty near Xi'an, Shaanxi; and stone statues of the Eastern Han dynasty (A.D. 9–220) and Six Dynasties period (A.D. 220–589) that line the "spirit roads" leading to tombs of the imperial family and prominent officials. Consult Li Ling, "Lun Zhongguo de you yi shen shou" [Discussion of Chinese Winged Beasts], *Zhongguo xueshu* [China Scholarship] 1 (2001), pp. 62–134.
2. See Xi'an Administrative Bureau of Cultural Relics, "Xibei yiliao meibeichang fuliqu 92 hao Han mu qingli jianbao" [Brief Report on the Excavation of Han Tomb Number 92 in the Residential Area of Northwest Medical Equipment Factory], *Kaogu yu wenwu* [Archaeology and Cultural Relics] 5 (1992), pp. 33–38; Han Guohe and Cheng Linquan, "Xibei yiliao sheluechang fuliqu 92 hao Han mu qingli jianbao" [Some Issues Concerning the Funeral Objects of Han Tomb Number 92], ibid., pp. 83–86; Han Baoquan, *Xi'an Longshouyuan Han mu* [Han Tombs in Longshouyuan, Xi'an] (Xi'an, 1999), pp. 112–24; and Li (note 1), fig. 16.
3. For a reconstructed set, see New York, J. J. Lally and Company, *Ancient Chinese Tomb Sculpture*, sale cat. (New York, Mar. 22–Apr. 10, 2004), cat. no. 1.
4. These include *qilin* (perhaps a transliteration of *griffin*); *yishou* (winged beast); *bixie* (one who wards off evil); and *tianlu* (one who brings heavenly fortune).

Yamantaka, pp. 34–35.

1. This figure, initially published as Yama, the Hindu god of death, was reidentified as Yamantaka by Associate Professor Robert Linrothe, Skidmore College. See New York, Sotheby's, *Indian and Southeast Asian Art*, sale cat. (New York, Sept. 16, 1999: lot 45a); and Robert Linrothe to Stephen Little, Nov. 1, 1999, files of the Department of Asian Art, The Art Institute of Chicago.

2. A detailed iconographic and stylistic history of this deity is provided in Robert Linrothe, *Ruthless Compassion: Wrathful Deities in Early Indo-Tibetan Esoteric Buddhist Art* (London, 1999), pp. 62–73, 162–76. For additional examples, see Marilyn M. Rhie and Robert A. F. Thurman, *Wisdom and Compassion: The Sacred Art of Tibet*, exh. cat. (New York, 1991), esp. pp. 232–35, 283–87.

3. See Albert Lutz, "Buddhist Art in Yunnan," *Orientations* 23, 2 (Feb. 1992), pp. 46–50, and accompanying references to the Qianxun Pagoda, located in the western city of Dali; and Luo Zhewen, *Ancient Pagodas in China* (Beijing, 1994), p. 198. The pagoda is thought to have been constructed in the late ninth century, but copper plates discovered inside document a series of repairs beginning in the eleventh and twelfth centuries. The Dali region became part of China under the Yuan dynasty of the Mongols (1279–1368).

4. See Helen B. Chapin, "A Long Roll of Buddhist Images IV," revised by Alexander C. Soper, *Artibus Asiae* 33, 1/2 (1971), p. 124, pl. 46, no. 120; and Wen C. Fong and James C. Y. Watt, *Possessing the Past: Treasures from the National Palace Museum, Taipei*, exh. cat. (New York, 1996), p. 217, fig. 82. This long hand-scroll painting, also known as the *Daliguo Fanxiang tu* [Picture of Buddhist Images from the Country of Dali], was executed as individual album leaves.

Mahamayuri Vidyaraja, pp. 36–37.

1. See James Cahill, *Chinese Painting* (Geneva, 1960), p. 51.

Willow Bridge and Waterwheel, pp. 40–41.

1. Only five paintings have been attributed to Sōya, who was the son of the renowned painter Hasegawa Tōhaku. These include *Dragon and Tiger*, a pair of screens in the Manno Museum, Osaka; a votive panel in Yasaka Shrine, Kyoto; a votive panel in Kiyomizu Temple, Kyoto; and *Katsura and Insects*, a pair of screens in a private collection. For the screens in the Manno Museum, see Manno bijutsukan [Manno Art Museum], *Manno korekushon senshū* [Selected Masterpieces of the Manno Collection], exh. cat. (Osaka, 1988), cat. no. 19. For *Katsura and Insects*, see Yamane Yūzō, "Katsura ni konchū zu byōbu ni tsuite" [Concerning the Screen *Katsura and Insects*], *Kobijutsu* 4 (Mar. 1964), pp. 119–20.

Resting in the Shade, pp. 42–43.

1. See Kendall H. Brown et al., *Taishō Chic: Japanese Modernity, Nostalgia, and Deco*, exh. cat. (Honolulu, 2002), p. 40.

2. Other recent acquisitions in this area include *Heron Maiden* (c. 1920s; 2000.477) by Nakamura Daizaburō (1898–1947) and *Beauty under the Cherry Blossoms* (c. 1930s; 2000.478) by Enomoto Chikatoshi (1898–1973).

Vase, pp. 44–45.

1. Quoted in Bernard Leach, *Hamada: Potter* (Tokyo/New York, 1975), p. 94.

Hindu Goddess, Possibly Uma, pp. 46–47.

1. See Jean Boisselier, "The Art of Champa," in Emmanuel Guillon, *Hindu-Buddhist Art of Vietnam: Treasures from Champa*, trans. Tom White (Trumbull, Conn., 2001), p. 39.

2. For more on Cham sculpture, see Gilles Beguin, *L'Inde et le monde indianisé au Musée national des arts asiatiques, Guimet* (Paris, 1992); Guillon (note 1); and Philippe Stern, *L'Art du Champa, ancien Annam, et son évolution* (Paris, 1942).

3. See Jean Boisselier, *La Statuaire du Champa: Recherches sur les cultes et l'iconographie*, Publications de l'École française d'Extrême-Orient 54 (Paris, 1963), pp. 128–29. Boisselier described a late-ninth- to early-tenth-century image of another goddess sculpture as having "a thick-lipped mouth with upward curving corners, but lacking the smile which would appear at a later date."

The Lord Who Is Half Woman (Ardhanarishvara), pp. 48–49.

1. For more on this period, see Vidya Dehejia, *Art of the Imperial Cholas* (New York, 1990). Select pieces from the Art Institute's collection of Indian sculpture have been published in Pratapaditya Pal, "Sculptures from South India in

The Art Institute of Chicago," *Art Institute of Chicago Museum Studies* 22, 1, pp. 21–35. This *Ardhanarishvara* appears as cat. no. 25 in idem, *A Collecting Odyssey: Indian, Himalayan, and Southeast Asian Art from the James and Marilynn Alsdorf Collection*, exh. cat. (Chicago, 1997).

2. This translation of *lupadakha* is taken from C. Sivaramamurti, *Indian Sculpture* (New Delhi, 1961), p. 1.

3. For more on Shiva, see Stella Kramrisch, *Manifestations of Shiva*, exh. cat. (Philadelphia, 1981).

4. As translated in Wendy Doniger O'Flaherty, *Women, Androgynes, and Other Mythical Beasts* (Chicago, 1980), p. 317.

An Illustration to the "Baburnama," pp. 50–51.

1. Quoted from Stuart C. Welch, *The Art of Mughal India*, exh. cat. (New York, 1964), p. 15.

2. For more on the *Baburnama*, see Linda York Leach, *Mughal and Other Indian Paintings from the Chester Beatty Library* (London, 1995); Pratapaditya Pal, ed., *Master Artists of the Imperial Mughal Court* (Mumbai, 1991); Ellen S. Smart, "Paintings from the 'Baburnama': A Study in Sixteenth-Century Mughal Historical Manuscript Ilustrations," Ph.D. diss, University of London, 1977; and S. I. Tiuliaev, *Miniatiury rukopisy "Babur-Name"* [Miniatures of *Babur Namah*] (Moscow, 1960).

3. The first edition of the *Baburnama* had 580 folios that included 193 paintings. Three text folios and 108 paintings are extant, now dispersed. The Art Institute's folio, a historical narrative, is from this first edition, which was dispersed in London in 1913; see Ellen S. Smart in New York, Sotheby's, *Indian and Southeast Asian Art*, sale cat. (Sept. 21, 1995: lot 111).

4. The artists did not sign this painting; they are identified by a later inscription at the bottom of the sheet, which names two members of Akbar's atelier. Kanha worked on most of the illustrated manuscripts commissioned by Akbar, while Mansur, a junior artist, achieved fame in the court of Akbar's son Jahangir (r. 1604–1627); see Smart (note 3).

5. Akbar first met Europeans in 1572 and soon after commissioned art that reflected Western style.

6. For a translation of this episode, see Susannah Beveridge, *The "Baburnama" in English* (London, 1922), p. 248, quoted in Smart (note 3). A folio from a later edition of the *Baburnama*, now in the National Museum, New Delhi, depicts Kichik Khwaja just a moment before, still on horseback; see M. S. Randhawa, *Paintings of the "Baburnama"* (New Delhi, 1983), fol. no. 148, p. 77, p. 116, ill.

Saint Anthony Abbot, pp. 52–53.

1. The majority of these panels are now dispersed among various museums and private collections. For more on these, see John Pope-Hennessy, *Fra Angelico* (Ithaca, N.Y., 1974), figs. 22, 27a–d.

The Ecstasy of Saint Francis, pp. 56–57.

1. For Caravaggio's paintings in San Luigi dei Francesi, see Howard Hibbard, *Caravaggio* (New York, 1983), figs. 52, 56.

Saint Peter Penitent, pp. 58–59.

1. For more on these works, see Alfonso E. Pérez Sánchez and Nicola Spinosa, *Jusepe de Ribera, 1591–1652*, exh. cat. (New York, 1992), where they appear as cat. nos. 17 and 28, respectively.

Two Cows and a Young Bull beside a Fence in a Meadow, pp. 60–61.

1. For an illustration and discussion of this work, see Amy Walsh, Edwin Buijsen, and Ben Broos, *Paulus Potter: Paintings, Drawings, and Etchings*, exh. cat. (Zwolle, the Netherlands, 1994), pp. 74–75.

The Marsh, pp. 64–65.

1. For more on these paintings, see Alexandra R. Murphy, ed., *Return to Nature: J. F. Millet, the Barbizon Artists, and the Renewal of the Rural Tradition*, exh. cat. (Yamanashi, Japan, 1988), pp. 283–89.

Calf's Head and Ox Tongue, pp. 66–67.

1. For more on *Paris Street; Rainy Day* and Caillebotte in general, see Anne Distel et al., *Gustave Caillebotte: Urban Impressionist*, exh. cat. (Chicago/New York, 1995), esp. cat. no. 35.

Notes

2. For Caillbotte's still lifes, see Distel et al. (note 1), pp. 230–53.

Young Woman in a Garden, pp. 68–69.
1. See this unsigned review in *Artist* 4 (May 1, 1883), pp. 137–38; repr. in Kate Flint, ed., *Impressionists in England: The Critical Reception* (London, 1984), p. 61.

Girl Looking out the Window, pp. 70–71.
1. Louise Lippincott, *Edvard Munch: Starry Night* (Malibu, Calif., 1988), p. 31.
2. See, for example, Wolfgang Kirschenbach, "Kunst und Wissenschaft," *Dresdener Nachrichten* 139 (May 19, 1893), n. pag.
3. For more on these motifs in German Romantic painting, see Joseph Leo Koerner, *Caspar David Friedrich and the Subject of Landscape* (New Haven, 1990).

Lovers Surprised by Death, pp. 72–73.
1. See David Landau and Peter Parshall, *The Renaissance Print, 1470–1550* (New Haven, 1994), p. 198. The authors characterized this woodcut as "the earliest we know to have been printed in three blocks—two tone blocks accompanying a highly abbreviated line block."
2. *Lovers Surprised by Death* was probably intended to replicate the effect of the chiaroscuro drawings of this period, which were made in pen-and-ink and wash on papers prepared with colored grounds. The second color variant of the first state (state 1b), of which the Art Institute's impression is an example, is printed in three subtle shades of brown, giving something of the nuanced effect of a drawing in brown wash.
3. Barbara Butts et al., *Men, Women, and God: German Renaissance Prints from St. Louis Collections*, exh. cat. (St. Louis, 1997), p. 23.

An Allegory: The Phoenix, or The Statue Overthrown, pp. 74–75.
1. See Frederick Schmidt-Degener, "Over Rembrandt's Vogel Phoenix," *Oud Holland* 42 (1925), pp. 191–208.
2. See J. D. M. Cornelissen, "Twee allegorische ersten van Rembrandt," *Oud Holland* 58 (1941), pp. 130–34.
3. See J. A. Emmens, *Verzameld Werk* (Amsterdam, 1979), vol. 2, pp. 239–42.

Jean Joseph and Anne Jeanne Cassanea de Mondonville, pp. 76–77.
1. Quoted in Albert Besnard, *La Tour: La Vie et l'oeuvre de l'artiste* (Paris, 1928), p. 54.
2. Pierre Jean Mariette, *Abecedario de P. J. Mariette : Et Autres Notes inédites de cet amateur sur les arts et les artists*, vol. 3 (Paris, 1854–56), pp. 73–74.

The Valley of the Eisek near Brixen in the Tyrol, pp. 78–79.
1. Alexander Cozens's best-known publication is his *New Method of Assisting the Invention in Drawing Original Compositions of Landscape* (1786). For more on both father and son, see Kim Sloan, *Alexander and John Robert Cozens: The Poetry of Landscape*, exh. cat. (New Haven, 1986), chaps. 1–3.
2. See Andrew Wilton, *The Art of Alexander and John Robert Cozens*, exh. cat. (New Haven, 1980), p. 15.

Corte del Paradiso, pp. 80–81.
1. The style of the frame is typical of Whistler's designs of the 1890s, which suggests that the drawing might have been reframed a decade or more after it was created. See Margaret F. MacDonald, *James McNeill Whistler: Drawings, Pastels and Watercolors: A Catalogue Raisonné* (New Haven, 1995), cat. no. 784.
2. For more information about the Ruskin suit, see Linda Merrill, *A Pot of Paint: Aesthetics on Trial in "Whistler v. Ruskin"* (Washington, D.C., 1992).
3. For more on Whistler and Venice, see A. I. Grieve, *Whistler's Venice* (New Haven, 2000); and Margaret F. MacDonald, *Palaces in the Night: Whistler in Venice* (Aldershot, England, 2001).
4. Margaret F. MacDonald in Richard Dorment and Margaret F. MacDonald, *James McNeill Whistler*, exh. cat. (London, 1994), cat. no. 111.

The Carrot Puller, pp. 82–83.
1. A closely related drawing is in the Kröller-Muller Museum, Otterlo, the Netherlands; see Johannes van der Wolk, Ronald Pickvance, and E. B. F. Pey, *Vincent Van Gogh: Drawings*, exh. cat. (Milan/Rome, 1990), cat. no. 115.
2. For an illustration of *The Potato Eaters*, see Evert van Uitert, Louis van Tilborgh, and Sjraar van Heugten, *Vincent Van Gogh: Paintings*, exh. cat. (Milan/Rome, 1990), cat. no. 7.

3. For examples of these studies, see van der Wolk et al. (note 1), cat. nos. 97–98, and van Uitert et al. (note 2), cat. nos. 5–6.
4. See Griselda Pollock, "The Ambivalence of the Maternal Body: Re/drawing Van Gogh," in *Differencing the Canon: Feminist Desire and the Writing of Art's Histories* (New York, 1999), p. 43.
5. Ibid.

Design for a Fan, pp. 84–85.
1. For more on these and Gauguin's other fan designs, see Jean Pierre Zingg, *The Fans of Paul Gauguin*, trans. by Simon Strachan (Papeete, Tahiti, 2001).
2. For an illustration of *Where Do We Come From?*, see George T. M. Shackelford et al., *Gauguin Tahiti*, exh. cat. (Boston, 2004), cat. no. 144. For *Riders on the Beach*, see Richard Brettell et al., *The Art of Paul Gauguin*, exh. cat. (Washington, D.C., 1988), cat. no. 278.

The Weeping Woman I, pp. 86–87.
1. For an illustration of *Guernica*, see Judi Freeman, *Picasso and the Weeping Women: The Years of Marie-Thérèse Walter and Dora Maar*, exh. cat. (Los Angeles, 1994), pp. 62–63.
2. For more on this series of works, see ibid.
3. For photographs and paintings of Dora Maar, see ibid., pp. 176, 179–80, 194.
4. For an illustration of Titian's *Mater Dolorosa*, see National Gallery of Art, Washington, D.C., and Palazzo ducale, Venice, *Titian: Prince of Painters*, exh. cat. (Munich, 1990), p. 92.

Black and White, pp. 88–89.
1. See Ellen Landau, *Lee Krasner: A Catalogue Raisonné* (New York, 1995), pp. 100–116, for examples of this series.
2. For illustrations of the surviving 1951 paintings and examples of the cannibalized collage paintings, see ibid., pp. 252–53 and 290–96, respectively.
3. Pollock made collages as early as 1943; see Francis Valentine O'Connor and Eugene Victor Thaw, eds., *Jackson Pollock: A Catalogue Raisonné of Paintings, Drawings, and Other Works* (New Haven, 1978), vol. 4, p. 97. He subsequently produced variants of the collage technique, often crossing over into paintinglike objects, as did Krasner. Pollock's collage *Untitled* (c. 1951; Washington, D.C., Phillips Collection) most closely resembles *Black and White* because in that work Pollock incorporated cannibalized scraps of drawn sheets, creating an overtly pictorial composition; for a reproduction of *Untitled*, see ibid., p. 116.
4. Pollock created many works indebted to Picasso; see, for example, O'Connor and Thaw (note 3), vol. 3, cat. nos. 635–36, 726, in which Pollock took inspiration from Picasso's *Guernica* (1937; Madrid, Museo del Prado).
5. For the latter interpretation, see Landau (note 1), p. 130.

Alka Seltzer, pp. 90–91.
1. Emily Bardack Kies, *The Drawings of Roy Lichtenstein*, exh. brochure (New York, 1987), n.pag.
2. For an overview of Lichtenstein's drawings from this period, see Diane Waldman, *Roy Lichtenstein: Drawings and Prints* (New York, 1970), and Bernice Rose, *The Drawings of Roy Lichtenstein*, exh. cat. (New York, 1987).
3. Quoted in "Artist Roy Lichtenstein, a Leader of Pop Painting," *Chicago Tribune*, Sept. 30, 1997, p. 10.
4. Benday dots comprise a textured screen that is used in commercial printing as a substitute for areas of continuous tone or color.
5. See Bonnie Clearwater, *Roy Lichtenstein: Inside/Outside*, exh. cat. (North Miami, Fla., 2001), p. 30.
6. For an overview of the artist's paintings, see Diane Waldman, *Roy Lichtenstein*, exh. cat. (New York, 1993).

Partly on This Side, Partly on the Other Side (Teils Diesseits teils Jenseits), pp. 92–93.
1. See Jutta Nestegard, "Sigmar Polke—*Apparizione* in the North," in *Sigmar Polke: Alchemist* (Humlebaeck, Denmark, 2001), pp. 9–11.
2. See Charles W. Haxthausen, "The Work of Art in the Age of Its (Al)Chemical Transmutability: Rethinking Painting and Photography after Polke," in *Sigmar Polke: The Three Lies of Painting* (Ostfildern, Germany, 1997), p. 192.